IMAGES
of America

WOODINVILLE

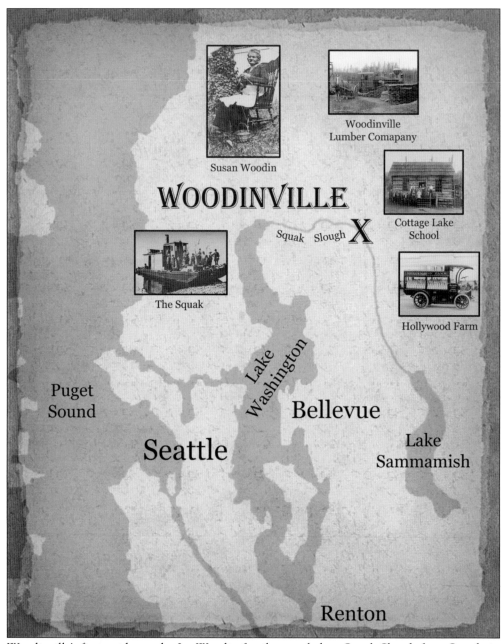

WOODINVILLE

Susan Woodin

Woodinville
Lumber Comapany

Squak Slough X

Cottage Lake
School

The Squak

Hollywood Farm

Lake
Washington

Puget
Sound

Bellevue

Seattle

Lake
Sammamish

Renton

Woodinville's first residents, the Ira Woodin family, traveled up Squak Slough from Seattle in 1871 to homestead 160 acres along its banks. The slough was the primary means of travel for early settlers until the railroads arrived in 1887. The slough was also the focus for the logging industry, which situated mills along its banks. The mills were the settlement's main employers until agriculture and businesses arrived.

ON THE COVER: Woodinville's first business, the Woodin-Sanders store, was founded in 1888 by Ira Woodin and his son-in-law Thomas Sanders (see page 13).

IMAGES
of America

WOODINVILLE

The Woodinville Heritage Society

ARCADIA
PUBLISHING

Published by Arcadia Publishing
Charleston, South Carolina

Printed in the United States of America

Library of Congress Control Number: 2014948491

For all general information, please contact Arcadia Publishing:
Telephone 843-853-2070
Fax 843-853-0044
E-mail sales@arcadiapublishing.com
For customer service and orders:
Toll-Free 1-888-313-2665

Visit us on the Internet at www.arcadiapublishing.com

CONTENTS

ACKNOWLEDGMENTS

The Woodinville Heritage Society is grateful to all those who contributed to this project so we could tell the story of our community.

This project would not have been possible without those who provided the images. Unless otherwise noted, all images are from the collection of the Woodinville Heritage Society (WHS). We are grateful to the individuals who provided them to WHS: Barbara Donnelly, Joe George family, Bob Crim, Mary McKee, Woodin family, Norm Perkins, Judy Neilson, Jerome Bosley, Terry Jarvis, John Cooper, John Halver, Gene Mack, Scott Housekeeper, Nick Uren, Wayne and Virginia Gibbs, Russ and Ursie Rogers, Linda Shipway, Stephen and Ida May Brown, Dorie Zante, Ed Zanassi, Ken Hall, Molbak family, James Kraft, Tom Downer, Joe Wilwerding, Fred Fletcher, Elsie Mann, Board family, Chuck Lee, DeYoung family, Paul Thomas, Daniel Cozine, Jonathan Morrison, and Kevin Cruff Photography.

We would also like to thank and acknowledge the following for allowing use of their photographs: University of Washington Libraries Special Collections (UWLSC), Museum of History and Industry (MOHAI), Washington State Archives Puget Sound Branch, King County property record cards (WSAPSB), and Northshore School District.

WHS wishes to thank the team that made this project a reality: Suzi Freeman, Judy Moore, Phyllis Keller, Kevin Stadler, and Gloria Kraft contributed many hours of research and fact checking. Two other team members were invaluable to this publication: James Kraft digitized the photographs, and Terri Malinowski wrote and edited the text.

INTRODUCTION

When Ira and Susan Woodin rowed across Lake Washington from Seattle and up the winding Squak Slough in 1871, they were not intending to found a settlement bearing their name. On that rainy day, the Woodins and their two small daughters were simply seeking a new home site and more land. They preempted 160 acres beside a bend of the slough and built a home that soon hosted the first post office, school, and Sunday school for the fledgling community. Their home rapidly became a stopping-off point for travelers between Seattle and the settlements upstream.

Logging camps and shingle mills emerged amid the heavily timbered landscape, and the slough provided transportation for the workers as well as a flue to float logs downstream to the mills. In 1887, the Seattle, Lake Shore & Eastern Railway extended its tracks beyond Woodinville. Travelers now had another form of transportation, accelerating the development of Woodinville and the Squak River Valley, later renamed the Sammamish.

The community was christened Woodinville, and early businesses sprang up along the railroad. The first was the Woodin-Sanders Store, built on pilings near the railroad depot in 1888. Others ranged from general stores and hotels to an adjustable school desk factory. Schoolhouses dotted the landscape in tandem with a community church.

A web of roads, trails, and bridges linked Woodinville to satellite settlements such as Cottage Lake, Derby (later Hollywood), and Grace. The community welcomed Molbak's Greenhouse in 1956, and its Danish owners grew the business into today's internationally known garden center. Other enterprises emerged in the 20th century, including those specializing in wine, laying hens, beef cattle, roses, goats, swans, mink, and honey. Even Norm's Resort on Cottage Lake became a national byword as a result of its bumper stickers.

Woodinville grew up officially when it incorporated in 1993. This decision led to a city hall, museum, community center, parks, and sports fields. Today, an official tourism district promotes more than 100 wineries, tasting rooms, distilleries, and breweries—the newest enterprises in a community that never stops growing.

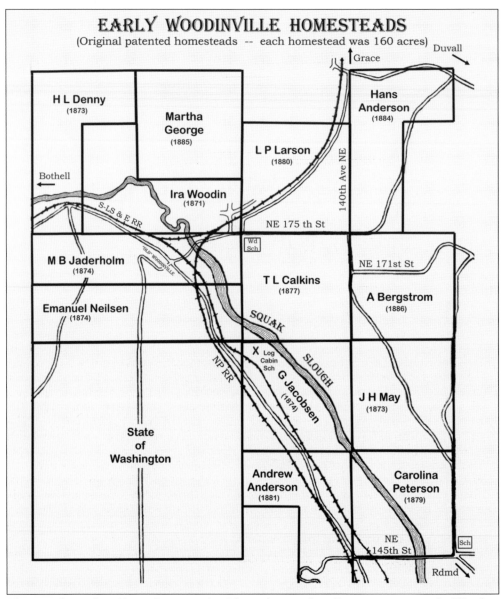

EARLY WOODINVILLE HOMESTEADS
(Original patented homesteads -- each homestead was 160 acres)

Duvall

Grace

H L Denny
(1873)

Martha
George
(1885)

Hans
Anderson
(1884)

L P Larson
(1880)

Bothell

Ira Woodin
(1871)

140th Ave NE

S-LS & E RR

NE 175 th St

Wd
Sch

"OLD" WOODINVILLE

M B Jaderholm
(1874)

NE 171st St

T L Calkins
(1877)

A Bergstrom
(1886)

Emanuel Neilsen
(1874)

SQUAK

X Log
Cabin
Sch

SLOUGH

NP RR

G Jacobsen
(1874)

J H May
(1873)

State
of
Washington

Andrew
Anderson
(1881)

Carolina
Peterson
(1879)

NE
145th St

Sch

Rdmd

This map shows the 160-acre homesteads of the earliest settlers. First to arrive were the Woodins in 1871, followed by H.L. Denny in 1873, and Gustav Jacobsen, Emanuel Neilsen, and Mary B. Jaderholm in 1874. Settlers could prove up their homesteads by paying $10, building a home, and living there five years before receiving title, or they could buy the tract outright for $200, which is what the Woodins did.

One

EARLY YEARS

In 1871, Ira and Susan Woodin set off from Seattle in a wooden boat, seeking a new home beyond Lake Washington. Rowing across the lake with two young daughters and their family possessions, the Woodins entered the mouth of Squak Slough, now the Sammamish River, and headed upstream. The word *squak* came from the Duwamish Indian word *squowh*, which means swampy.

In choosing a forested tract beside the slough, the Woodins' nearest neighbor was a bachelor two miles downstream. A small band of the Simump tribe roamed the streams and forests. Susan Woodin learned some of the Chinook language so she could communicate with them. As more homesteaders arrived, the Woodin home became the first post office, school, and church.

By 1887, the Seattle, Lake Shore & Eastern Railway had built a rail line around the lake to the fledgling settlement, sending one branch north toward Snohomish and the other south to Issaquah. Trains replaced the scows and passenger boats that once transported people and supplies. The major industry was logging, with numerous sawmills and shingle mills. A rough road ran eastward from Woodinville to Duvall, with a stagecoach line operating between the towns. Woodinville and its satellite communities of Cottage Lake, Derby, and Grace each had a school, sometimes just a crude cabin, but later, frame and even two-story brick structures.

In the early 1900s, Hollywood Dairy Farm and Hollywood Poultry Farm were followed in the valley by sprawling truck gardens nurtured by Italian and Asian families. The rich loam yielded abundant vegetables, trucked to Seattle produce markets. Businesses like DeYoung Mercantile and Molbak's Greenhouse flourished, the latter becoming one of the largest garden centers in America.

A tourism district now promotes 100-plus wineries and tasting rooms. Coupled with Molbak's, the attractions draw over one million visitors a year. Today, nearly 150 years later, the Woodins' 160-acre homestead has been enveloped by an incorporated city of 11,000 with parks, municipal buildings, and sports fields.

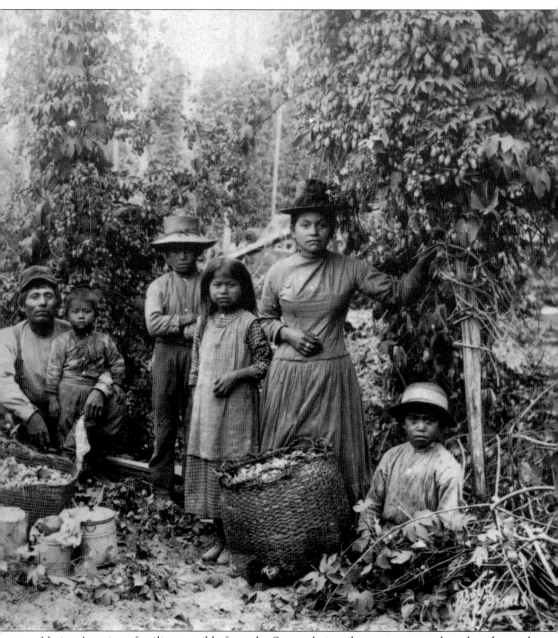

Native American families, possibly from the Snoqualmie tribe, were among those hired to pick hops in western Washington around 1890. Hop vines were grown on Gustav Jacobsen's homestead, west of Squak (later called Sammamish) Slough and south of the Woodinville bridge. Hops, an essential ingredient for brewing beer, were a big crop in several valleys—Squak, Snoqualmie, Kent, and Auburn. (Courtesy UWLSC NA4189.)

Amused members of the Ira Woodin family are pictured here around 1903 in front of their home on Squak Slough. Ira Woodin, 30, and Susan Campbell, 15, were married on New Year's Day 1863 in Seattle's second wedding. They homesteaded here in 1871, having rowed a boat across Lake Washington and up the slough. Their children, standing behind them, are, from left to right, Helen (Woodin) Keller, Frank Woodin, and Mary (Woodin) Sanders.

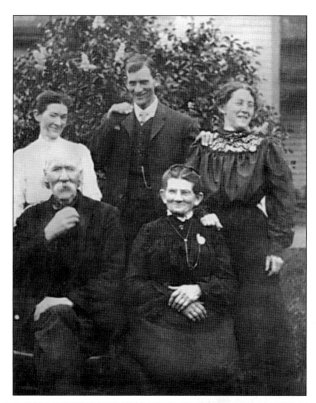

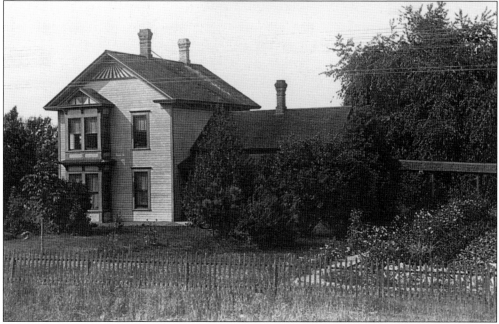

This substantial home replaced a smaller house the Woodin family lived in their first few years. The Woodins hosted the first post office, church, and schoolroom for the fledgling community at various times in their house. Ira Woodin provided doctoring since there was no physician within miles. The Woodins raised chickens, milk cows, orchard fruits, and vegetables on their homestead.

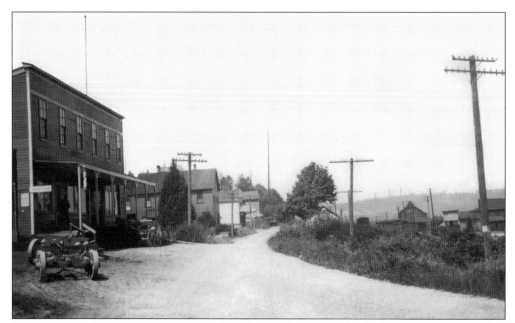

This postcard shows Front Street just after electrical power and telephone systems arrived in Woodinville, around 1912. The view is west toward Bothell, and the businesses along the left side are Dodd's Adjustable School Desk Factory, Parsons Hotel and Restaurant, Emanuel Neilsen's General Merchandise, and Teegarden's Shop. On the right side of Front Street are the railroad depot, Woodin-Sanders Store, and the Rainier Saloon.

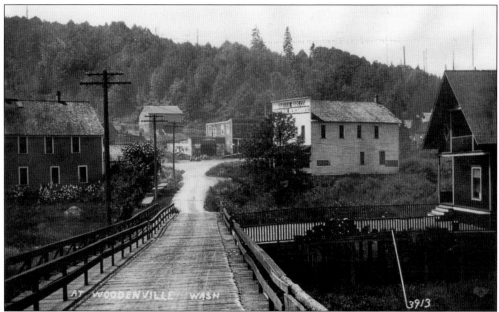

Pictured around 1912, this view from the bridge over Squak Slough (now the Sammamish River) captures, from left to right, the Hargus Hotel, Anders Hansen's barn on the hillside, John P. Koch's Blacksmith Shop attached to the Dodd Adjustable School Desk Factory, the Foresters' Lodge with Ruelle Brothers' Store on the first level, and the Ruelle home (far right) on pilings beside the river. The bridge offers a protected walkway for pedestrians.

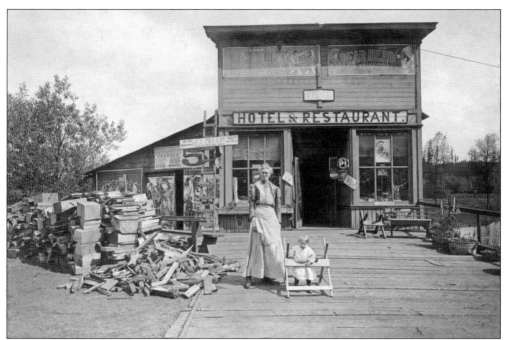

Ira Woodin and his son-in-law Thomas Sanders opened this store on pilings between Squak Slough (right, rear) and the railroad tracks in 1888. By 1911, the photograph shows a hotel and restaurant had been added. The ample wooden boardwalk connected the business to the railroad platform so passengers could get a meal without walking through mud. The woodpile was handy for stoking the stove inside. Signs on the building advertise Maplewood Ice Cream, a traveling show coming to Seattle, and the *Seattle Post-Intelligencer* newspaper ("P-I"). The photograph below shows a wooden sawhorse that has been converted into an early version of a walker by cutting out part of the upper rail for the child to lean into while standing.

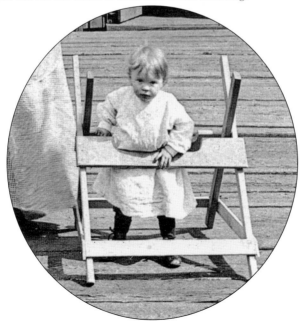

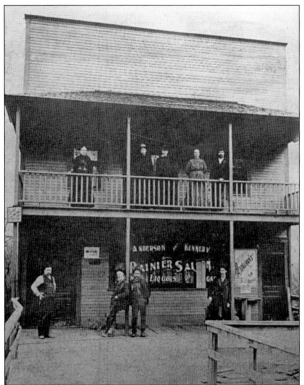

The Rainier Saloon was built on pilings beside the river in 1889, east of the Woodin-Sanders Store near the railroad depot. Proprietors were Vic Anderson (street level, far right) and C. Kennedy on behalf of owners Seattle Brewing and Malting Company. The second floor housed the Junction Hotel and a restaurant operated by Bill Bell (street level, second from right). On the balcony is Henrietta Bell (second from right).

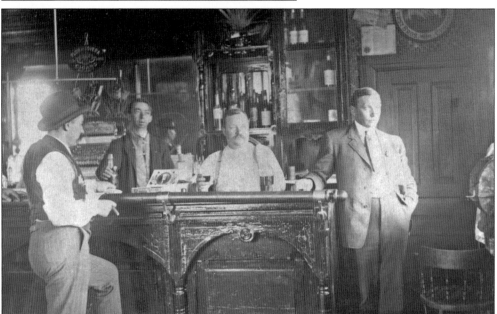

The Rainier Saloon was a popular watering hole for local citizens as well as railroad employees. Pictured here around 1904–1905 are, from left to right, Woodinville depot agent Ed Harcourt, John "Chinless" Hamilton, bartender and proprietor Vic Anderson, and Al Mack. The saloon was slated for closure in 1912 as a result of a citizen petition during the era of the Women's Christian Temperance Union.

Vic Anderson was Woodinville's first saloon keeper, presiding over his business built near Squak Slough in 1889. The saloon's proximity to the railroad depot meant the railroad men could alight during the brief stopover for a brew. Behind Anderson's saloon was the local barbershop, a little room containing a barber chair and tin bucket for hot water. Service depended on an itinerant barber passing through.

The Junction Hotel was located on the second floor of the Rainier Saloon, and was one of Woodinville's earliest businesses. The saloon building stood on pilings near the river and the railroad junction, where trains passed daily. The hotel and its restaurant catered to passengers and crews with rooms, food, and liquor, according to this advertisement, which appeared in the January 1, 1903, edition of the *Bothell Independent* newspaper.

. . Junction Hotel . .

Woodinville Wash.

A full and select line of Wines, Liquors and Cigars

Meals served at any hour . . .

· · · Rooms in connection

**"Crown Diamond" Whiskey
is our specialty**

C. Kennedy = = = Proprietor.

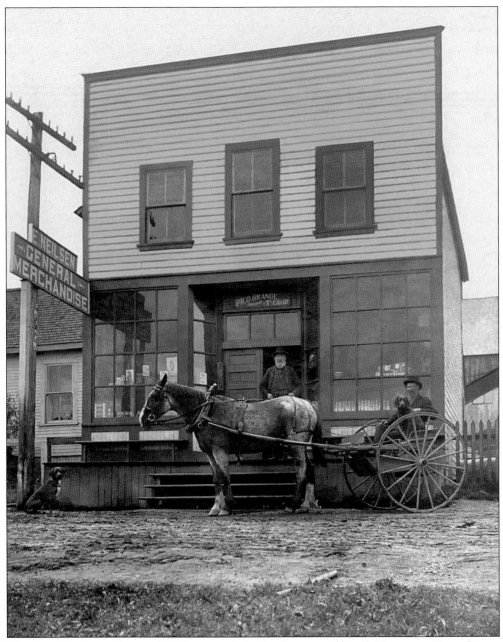

Woodinville pioneer Emanuel Neilsen stands in the doorway of his 1895 store on Front Street, with his family home visible at left. A customer has arrived with horse and carriage, bringing his two dogs, one sitting beside him and the other beside the power pole. The store approach allowed women to step onto the steps without muddying their skirt hems. The sign above the door reads "Pico Grande Superior 5¢ Cigar."

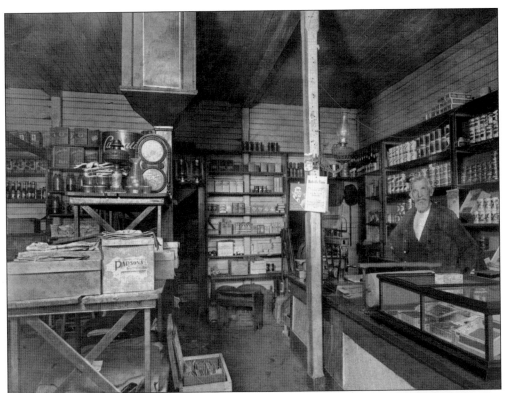

Emanuel Neilsen stands behind the counter of his general store around 1916. A hurricane lamp hanging on the central post probably ensures illumination, despite the arrival of electricity in 1910. The shelves display such items as Albers and Quaker rolled oats, tins of chewing tobacco, evaporated milk, corn syrup, blankets, brooms, and jars of catsup. Sausages hang behind Neilsen, and cigars stay fresh in the glass cases at right.

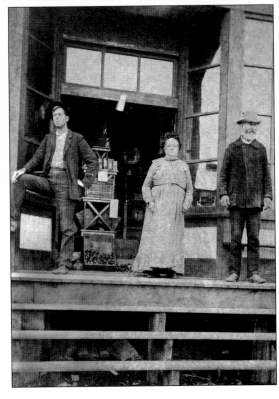

Emanuel Neilsen (right), his wife, Grete, and their grandson William "Billy" Jaderholm stand on the porch of the Neilsen store on Front Street, where today's historic Woodinville Mercantile stands. Neilsen and his brother Gustav Jacobsen immigrated from Norway in 1870 (Neilsen changing his surname from Jacobsen). Jacobsen, Neilsen, and Neilsen's daughter Mary B. Jaderholm each homesteaded 160 acres south of the Woodins in 1874. Neilsen built his store around 1895.

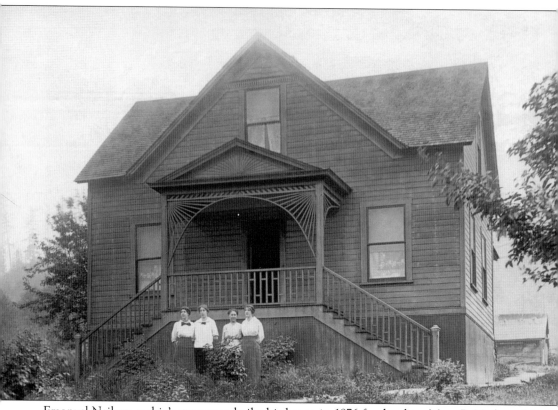

Emanuel Neilsen, a ship's carpenter, built this house in 1876 for daughter Mary B. Neilsen, 16, when she married logger Eric Jaderholm, 30. Neilsen used cedar off his land, assembling the house with wooden pegs. Jaderholm died in 1885, leaving Mary with two children. She proved up her 160-acre homestead and operated a boardinghouse until marrying Anders Hansen in 1889. Their daughters are, from left to right, Agnes, Margaret, Mary, and Helen.

Among the earliest homesteaders in the Sammamish Valley were Gustav and Anna Jacobsen in 1874, with 160 acres on the west side of the slough, south of the present bridge. Jacobsen later built this home and even developed a nine-hole golf course on his property. It is believed that the Jacobsens are the individuals pictured here around 1900, with daughters Clara and Sarah and son Edwin in the upper window.

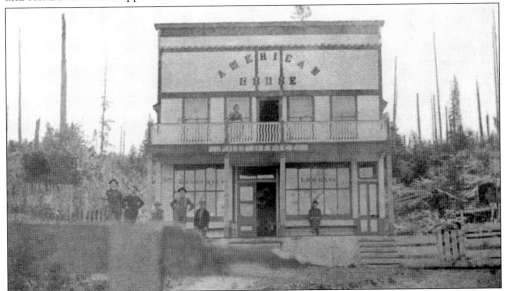

The American House, on the hillside of Front Street, was a combined grocery store (street level) and hotel (second floor). The sign just below the balcony indicates that it is also the post office. Developed by pioneer Emanuel Neilsen (seated on the front bench) and his grandson Billy Jaderholm, the store was managed by Al Chapin and the hotel by Neilsen's daughter Mary B. Neilsen Hansen. The structure burned down around 1900.

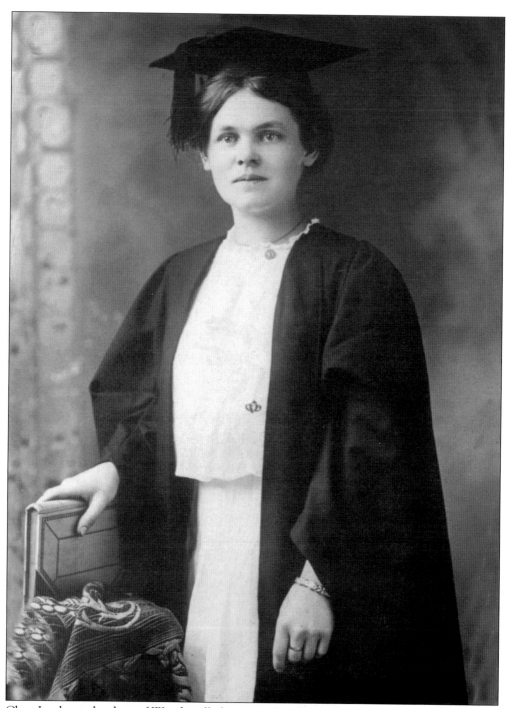

Clara Jacobsen, daughter of Woodinville homesteaders Gustav and Anna Jacobsen, graduated from the University of Washington and began teaching at Derby (later Hollywood) in 1898. Next was Woodinville's one-room wooden schoolhouse, where she taught 60 students. Jacobsen herself had been among the early pupils when her father built a log cabin school on his homestead about 1883. Later, she co-owned a store with her sister and married blacksmith Harry Teagarden.

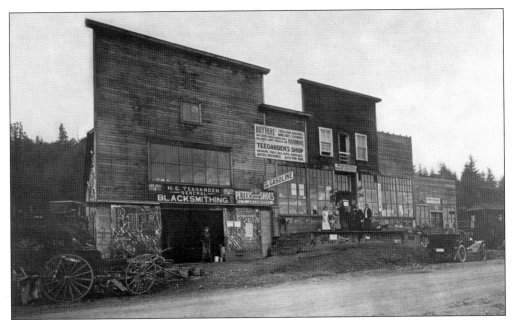

This false-front building on Front Street housed the Teegarden enterprises around 1916. Blacksmith Harry Teagarden (left, in doorway) operated the smithy but was already handling automobile repair and gasoline sales. The car pictured here is a 1915 Ford Model T. In 1914, after a long courtship, Teagarden married teacher Clara Jacobsen, who had operated the general store next door. She disagreed with the spelling of his surname, changing it to Teegarden.

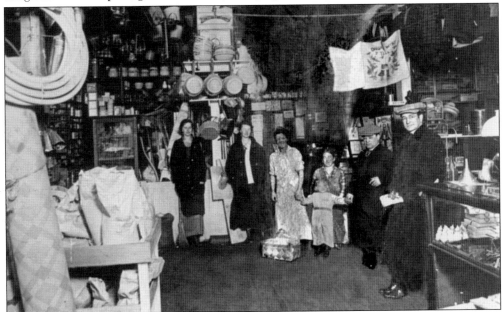

Clara Teegarden (center, in light dress) stands inside her store with some customers. The photograph reveals the wide variety of goods available. Known for her generous nature, Clara extended credit if customers did not have money for merchandise. Teegarden advertised in the *Bothell Sentinel* newspaper and even offered one-day clearance sales and coupon redemption programs, much like today's stores. The store also housed the Woodinville Post Office, of which she was postmistress.

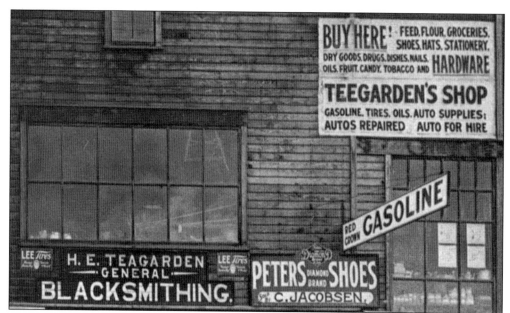

Two signs amusingly point out the spelling difference in their surname after shop owner and local teacher Clara Jacobsen finally married blacksmith Harry Teagarden in 1914. She did not like the spelling of his name and changed hers to Teegarden, while he retained the original spelling. Their side-by-side businesses occupied the same building on Front Street.

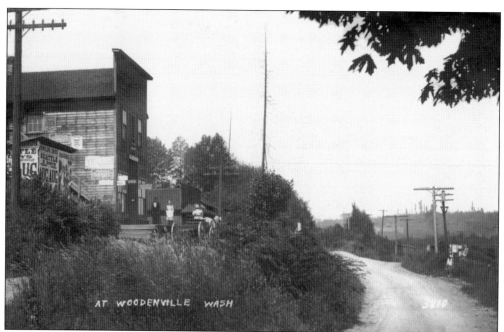

This store stood above Front Street in 1913, with an access lane in front. Milt Russell built the store around 1900, calling it Woodinville Grocery. He sold it in 1904 to Sarah Jacobsen and her sister Clara, a local teacher, who operated it jointly until Sarah wed in 1912. Clara gave up teaching to run the store, and the name changed to Teegarden Shop in 1914 when Clara married local blacksmith Harry Teagarden.

William and Annie Smith moved to Woodinville in 1904 and opened a meat market; Annie operated an adjacent restaurant. They are pictured here with their son Frank "Curly" on the porch of their nearby home. Meat was delivered on the express train daily from the Frye-Bruhn Meat Packing Company in Seattle. Since electricity (and refrigeration) did not come to Woodinville until 1910, the meat had to be sold rapidly to avoid spoilage.

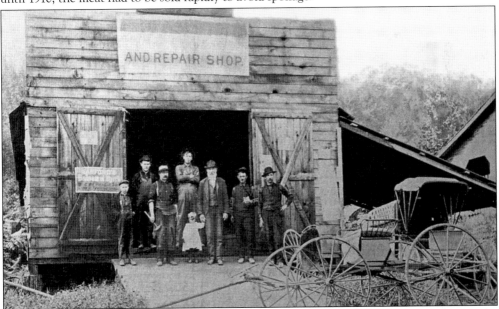

Early Woodinville settlers stand in front of John Dickson's Blacksmith Shop on Front Street. The partially legible sign reads "Blacksmithing and Repair Shop," according to an early newspaper article. The shop operated from approximately 1903 to 1905, apparently between Emanuel Neilsen's store and Parsons' Hotel and Restaurant, now the Woodinville Mercantile site. Pictured here are, from left to right, George Calkins, Virgil Bell, Smithy John Dickson, Billy Jaderholm, Jimmy Anderson (child), Emanuel Neilsen, Bill Smith, and Bill Hoffman.

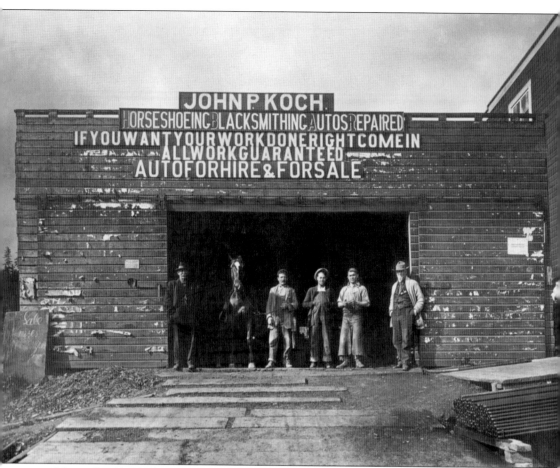

Johann Koch's blacksmith shop and sign on Front Street, pictured here around 1916, show his livelihood was about to change. While he still did horseshoeing and wagon repair, he was starting to repair automobiles as well as rent and sell them. In his smithy apron, Koch is the second man from the right in the doorway. The pipes stacked in the right foreground were to be used to channel spring water from the hillside above the shop.

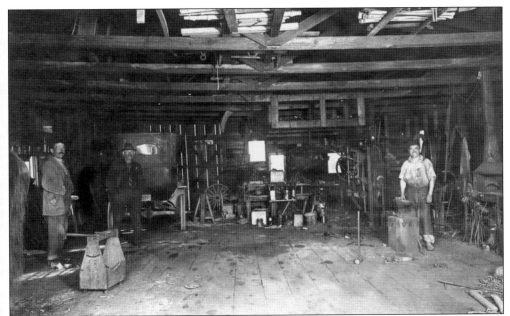

Johann Koch stands at right beside his blacksmith's anvil on Front Street. This view of the shop interior around 1916 confirms that Koch was repairing automobiles as well as shoeing horses. When a fire damaged his shop, he moved his smithy across the river opposite the cemetery, later the site of Woodinville Motors. Koch and others of German ancestry encountered some hostility during World War I. The advertisement below is from a 1924 edition of the *Bothell Sentinel* newspaper and describes Koch's services.

When you deal at home you are always assured
of reliable work at prices that are right

Let

Koch the Blacksmith

Attend to your blacksmith. wagon and woodwork

John P. Koch

Woodinville

BLACKSMITH : WHEELWRIGHT

Horseshoeing a Specialty

"WE KNOW HOW"

This 1902 portrait of John Emil Halver I, his wife, Hilda Sofia Halver, and their children, Marie and John Emil II, reflect the fashions of the period. The family lived in Marysville, Washington, at the time. Later, John Emil Halver II married Helen Hansen, and they settled in Woodinville on property next to the early homestead of her mother, Mary B. Hansen.

John Halver II and Helen Hansen, pictured here in Bellingham in 1916, "kept company" for six years until their 1918 marriage. Helen was the daughter of Anders and Mary Hansen and granddaughter of Woodinville pioneers Emanuel and Grete Neilsen. Halver served during World War I with the Engineer Corps, Spruce Division, in Vancouver, Washington, logging spruce to make airplanes.

Two

LOGGING AND MILLS

Logging was important to early settlers of the Squak Valley for several reasons. The valley and hills were a logging paradise with virgin stands of cedar and fir trees, nurtured by rain and mild weather. In removing the timber, pioneers cleared their properties, and the logs themselves became a source of income.

Using a team of oxen or horses, early loggers skidded the logs down trails to the river and into Lake Washington for sale to Seattle mills. These skid roads consisted of peeled logs laid several feet apart and heavily greased. Horse teams picked their way along, pulling logs behind them over the greased skids. Local residents like Frank Woodin, F.L. French, and Jesse Brown soon set up their own mills, turning logs into lumber or shingles. Then, enterprising men carved narrow-gauge rail lines deep into the forests, and the trains brought logs directly to local mills. Donkey engines replaced horse teams in hauling logs to the trains. A donkey engine was powered by a wood-burning boiler on skids, from which cables were attached to the logs for hauling.

Logging was steady work for the early settlers, although dangerous at times. A logging crew might have 15 men, and a mill might use 10. The dangers lay in falling trees, sharp saws, and the perilous task of riding rafts of logs down the river while keeping them from getting stuck along the banks.

From the 1880s well into the 20th century, the whine of saws, smell of fresh sawdust, and a pall of smoke over the valley were ever-present. Each mill might spawn a small community, often temporary, that usually contained a bunkhouse, homes, a small store, and perhaps a crude schoolhouse that doubled as a recreation center. But once logging operations and mills moved, these communities would wane and often vanish. For example, the small settlement of Paradise Lake and its school lasted but two years, 1901–1903, and only the cemetery remains. The settlements of Grace and Derby (later Hollywood) languished, but did not die completely.

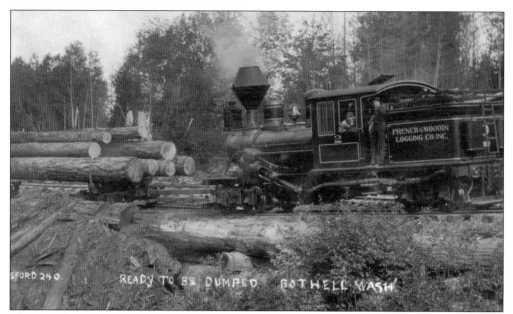

The French-Woodin Logging Company operated from 1909 to 1912 under the partnership of Frank Woodin and F.L. French. Their crews logged mainly in south Snohomish County, and the company log train ran south through Grace and along Bear Creek, dumping logs into the river near Bothell. These steam-powered trains were a familiar sight in the woods around Woodinville and Bothell early in the 20th century, replacing the horse teams used in earlier years.

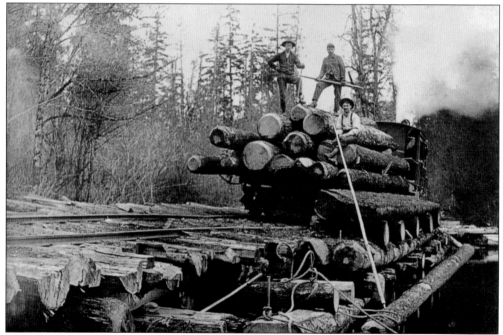

This load of logs is heading down a skid road that later became NE 171st Street, running in front of the Woodinville Heritage Museum. A brakeman would ride the load and hope the brakes would hold until the load reached the slough for dumping. Four horses would then pull the flatcar back up the hill to be reloaded. Hiram Wiltsey is on the left; the other men are unidentified.

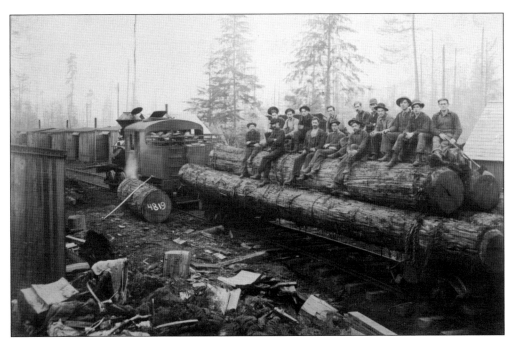

Like birds perched on a limb, the crew at Woodinville Lumber Company line up on a log for the photographer. This logging operation was located north of Woodinville, and the logs were slated for processing at the company mill in Grace. In the background are small cabins where the crew bunked while working at the camp.

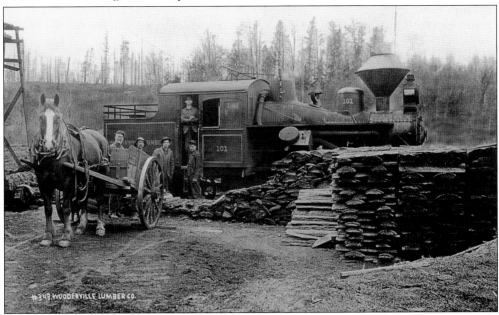

Crewmembers gather around the horse cart being used to haul away wood ends at Woodinville Lumber Company, near the settlement of Grace, operated by Jesse Brown and John Rebhahn from 1906 to 1911. When the tree supply thinned, Brown bought the Machias Lumber Company south of the Woodinville bridge from cofounders Col. B. Miller and C. Niemeyer. He renamed it Machias Mill Company and continued until 1926.

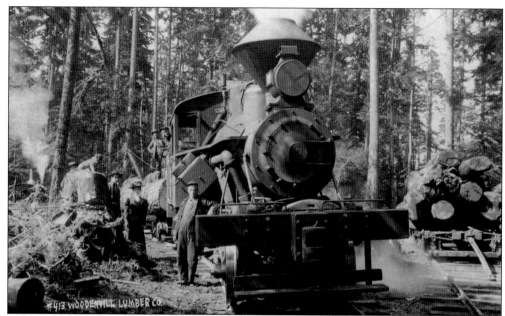

An early enterprise was the Woodinville Lumber Company, located in Grace just north of the county line. It was owned by Jesse Brown and John Rebhahn and operated from 1906 to 1911. In the photograph, the crew is hosting a female visitor in her Sunday best. Another spectator was the dog sitting atop a stump at left rear. Engine 101 hauled logs to the company mill in Grace, where there was a school, store, and company housing.

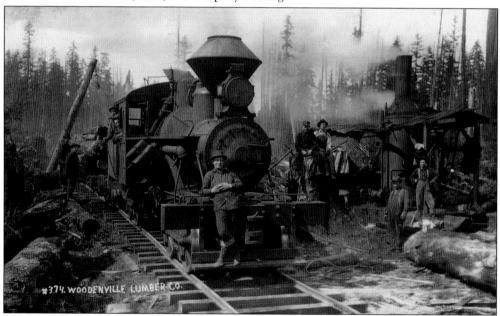

This photograph of the Woodinville Lumber Camp near Grace from around 1907 contains all the elements of a logging camp in the woods. The donkey engine at right provided power to operate the hoist in the left background, which stacked logs on the railroad flatcar. The engine would haul the logs to the Woodinville Lumber Company mill at Grace, where they would be processed into lumber and go by rail to Seattle.

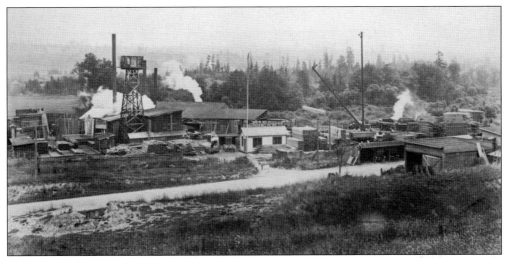

Machias Mill on the Sammamish Slough at Woodinville was a fairly large operation during its heyday between 1911 and 1926, as evidenced by the advertisement below from the *Bothell Sentinel* newspaper. Owned by Jesse Brown, the operation alongside the railroad tracks shows a loading boom lifting lumber with the help of five workmen. The road in the foreground is the present State Route 202 connecting Woodinville and Redmond.

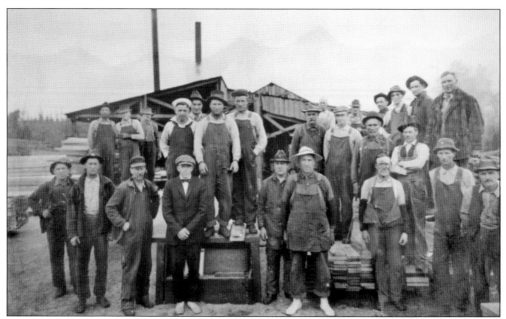

The crew of Machias Mill on the Sammamish Slough at Woodinville pauses for a photograph around 1911. Owner Jesse Brown is standing in the foreground at far right. His son Wallace Brown is the young lad wearing a white sailor-style cap standing on lumber at left center in the second row. The going wage for mill workers at this time was $2 for a 10-hour day.

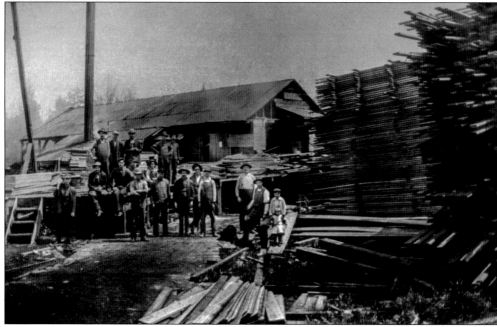

Jesse Brown owned and operated the Machias Mill, located along the river in Woodinville from 1911 to 1926. This 1912 photograph shows a mill crew of 16 and two children (right) standing beside Jesse Brown. The 1911–1912 Polk Business Directory for Woodinville lists the following officers of the mill: Jesse Brown (president and manager), Florence Brown (his wife and secretary-treasurer), and Blossom Brown (vice president).

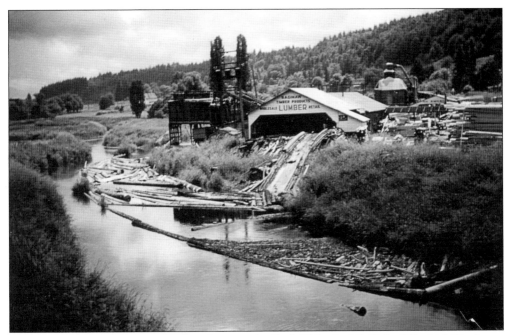

Saginaw Mill emerged in 1948 when four people, Dick Nobach, J.P. Cole, "Blackie" Blackmar, and Lois May, bought a longtime mill site on the slough south of the bridge. This photograph illustrates how using the slough for the mill's log storage could pose problems for boat navigation. Larkin Gibson bought the mill in 1972, but closed it in 1980 when mill equipment became dated and personnel reached retirement age.

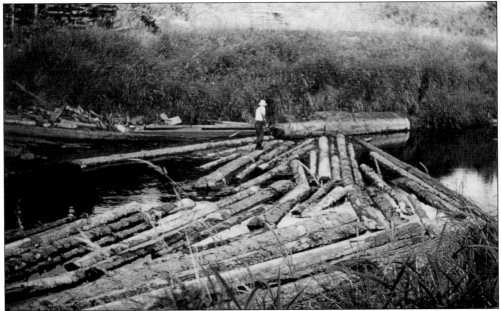

A nimble mill worker balances on shifting logs as he guides the results of a log dump into a semblance of a raft for temporary storage on the Squak (Sammamish) Slough until a nearby mill could process the timber into lumber. Waterborne craft plying the slough had to be vigilant in avoiding these challenges to safe navigation.

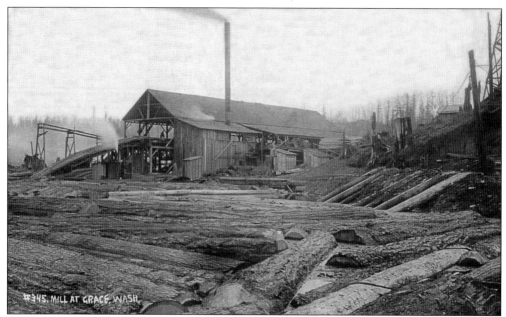

The Grace Mill Company began with brothers Henry and Allyn Carsten in 1898. The mill focused on shingles cut from bolts that were harvested from logging operations and floated down Little Bear Creek to the mill. Each bolt bore the mark of the originating camp to be credited when the bolt reached the mill. A grocery store, post office, and school soon opened nearby to serve the mill population.

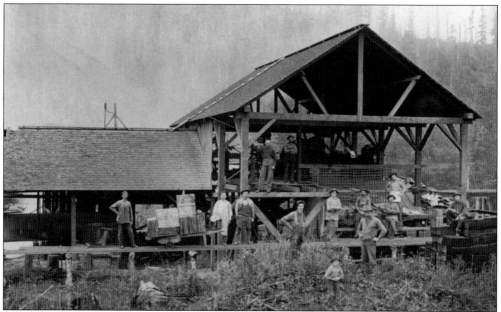

The short-lived Schafer and Raymond Mill, established around 1910, was one of numerous lumber mills in the Woodinville area. This one briefly operated across from the Grace schoolhouse but closed down within months on July 10, 1911, leaving this crew without jobs. It was said a logger named Charles Flaherty sued the mill owners, Arthur Schafer and R.L. Raymond, for an unspecified reason, hence the mill closure.

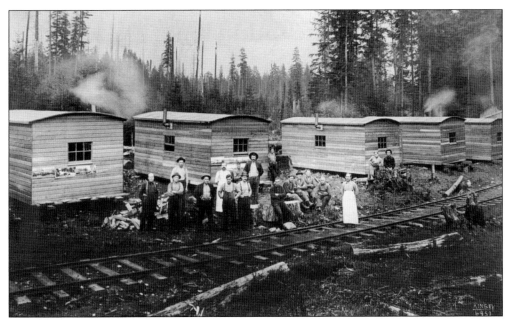

The families of early loggers followed the men when they could, as evidenced by this scene of a Campbell Lumber Company camp near present-day Mack's Corner. The company furnished basic dwellings close to the worksite, in this case alongside the train track. Here, the tract of land remained in the company name until 1948, when Guy Mack bought it and established a home and store with his son Gene.

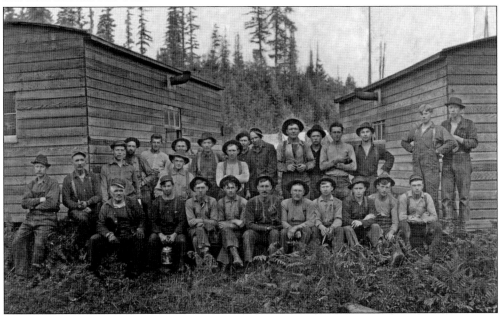

The size of this Campbell Lumber Company crew shows how many men were needed in a logging operation. The Campbell headquarters were in Redmond, but their operations involved much of the forested areas around Summit (later Leota), Cottage, and Paradise Lakes. Tax records illustrated the importance of lumbering to the early economy. Founded in 1905 and valued at $50,000, the logging and sawmill were assessed two years later at $170,000.

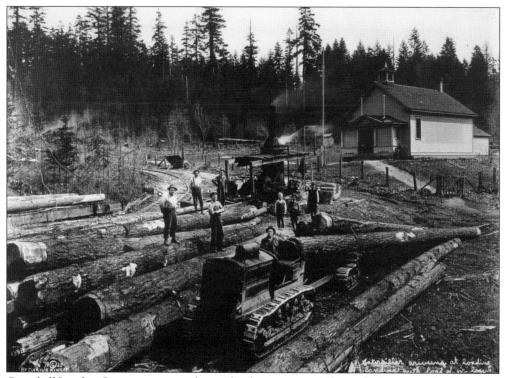

Campbell Lumber Company operated one of its logging camps alongside Cottage Lake School, at the site where the Avondale shopping complex now stands. The whine of the donkey engine often competed with lessons being taught inside by teacher Fay Erickson. One of the schoolchildren has joined the crew for this photograph. Below, the circumference of the logs is indicative of first-growth forests available to early timber companies.

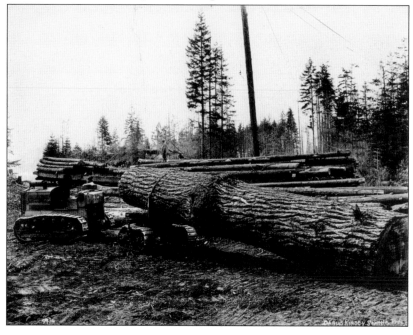

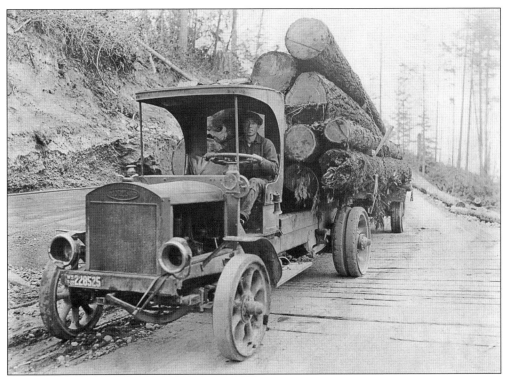

The Moreland truck (above) provided a sturdy, dependable means of transporting logs from remote Woodinville logging camps to the nearest mill or log-dump site when this photograph was taken in 1922. Notice the variety of road surfacing, which the driver must negotiate with his heavily loaded truck, rigid wheels, and open headlamp holders. By contrast, the Mack truck below traveling the same road has only one headlamp, mounted on the hood, but the tires are grooved deeper to grip the road surface. The driver's heavier load displays the size of trees harvested in Woodinville-area woods.

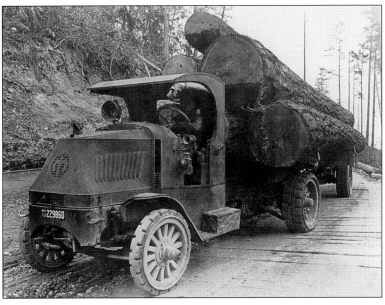

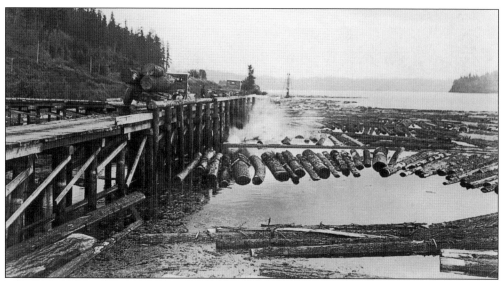

The Campbell Logging Company was a large presence on the east side of Lake Washington, now known as the Eastside, including extensive logging around Cottage Lake and Paradise Lake. Headquartered in Redmond, the company operated logging trains that pulled loads of logs regularly down the Eastside and onto a trestle to dump into Lake Sammamish (above). There the logs from several camps could be rafted together and boated to nearby lumber mills for processing.

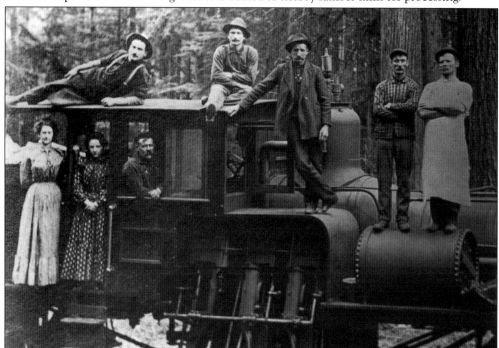

Itinerant photographers often captured scenes such as this logging crew taking a break to host their female visitors. At far right is the camp cook, an essential part of every logging operation. The locomotives hauled flatcars loaded with logs from the woods to the nearest log dump beside the river. Faint traces of paths carved by those train tracks can still be detected in wooded areas east of Woodinville.

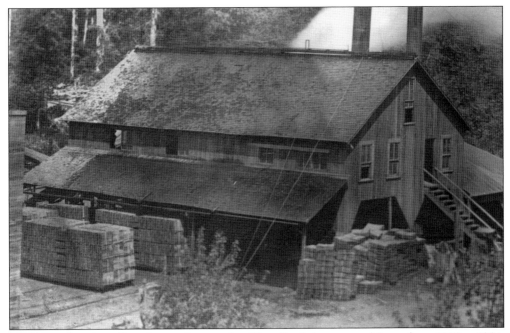

This large shingle mill on the southwest side of Paradise Lake operated from about 1900 to 1904. After cedar trees were logged and sent to the mills, the cedar stumps were harvested and turned into shingles by men called shingle weavers. Using a tool called a froe, they split the cedar bolt with fine precision. Stacks of bound shingles are visible outside the mill.

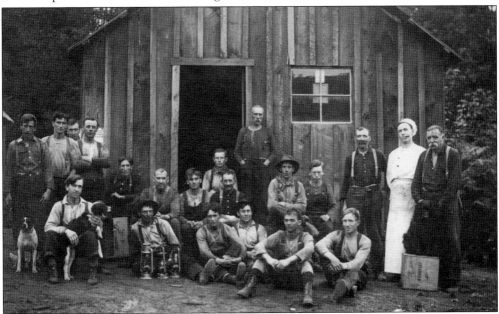

This mostly youthful crew at the Paradise Lake Shingle Mill worked long hours while the mill operated, from about 1900 to 1904. Some of them were married and had families (and pets like the two dogs at left). The crew members either lived nearby or in the bunkhouse behind them. Every camp had a cook, and this settlement even had a schoolhouse with 18 pupils. The building also served as a social hall.

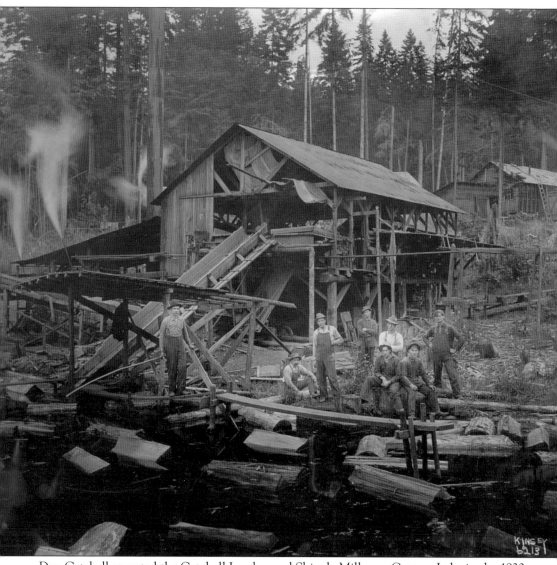

Dan Getchell operated the Getchell Lumber and Shingle Mill near Cottage Lake in the 1930s, but the mill burned down in 1939. Mills like this were vulnerable to fire, given the wooden framing, flammable wood trimmings, and proximity to a heat source. Getchell moved on to Woodinville, where he partnered with John DeYoung in establishing and operating the Woodinville Shingle Mill.

Three

RIVERS, RAILS, AND ROADS

Squak Slough (Sammamish River) was the initial highway into the wilderness for the first settlers of Woodinville arriving in the 1870s. The Ira Woodin family rowed from Seattle across Lake Washington and up the slough in search of a home site, followed by other families who entered the slough at Kenmore and traveled the twisting 13-mile route as far as its origin in Lake Sammamish.

By the 1880s, scows and passenger boats were plying the same route, delivering people and goods to Bothell, Woodinville, Derby, and Redmond. Shifting sandbars and half-buried snags called for careful navigation and shallow-draft boats powered by steam or 12-horsepower engines. The trip over the full course took up to 12 hours.

In 1885, a group of Seattle citizens formed the Seattle, Lake Shore & Eastern Railway, which followed the north shore of Lake Washington from Seattle to Woodinville, delivering passengers, mail, and cargo. At Woodinville, the rails split into one line heading north to Snohomish and the Canadian border while the other line ran south down the valley through Redmond to the coal fields around Issaquah.

Celebrating the arrival of daily train service, businesses began springing up around the Woodinville junction, and a spacious depot was built. By the early 20th century, trails connecting Woodinville with Bothell, Duvall, and Kirkland became dirt and gravel roads, which served local auto traffic as early as 1906.

A daily stage between Woodinville and the Valley House hotel in Duvall met the morning train and delivered passengers to Duvall within four hours, returning to Woodinville by nightfall. The coach, pulled by two large horses, followed a dusty, rutted road that in part became today's Woodinville-Duvall Road. Within a decade, a brick road replaced the route from Bothell to Derby (later Hollywood).

By the 1930s, some of the major roads were paved, and in the 1940s, Evergreen Trailways was offering daily bus service between Hollywood, Woodinville, and Seattle. The community by the river had arrived.

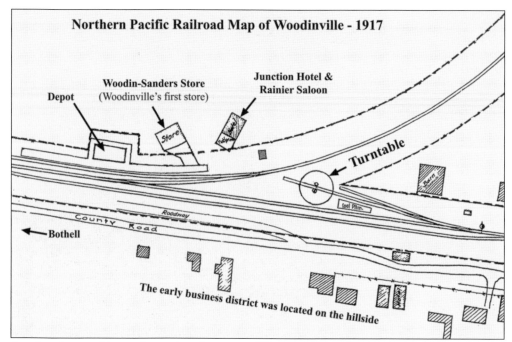

Northern Pacific Railroad Map of Woodinville - 1917

Depot

Woodin-Sanders Store
(Woodinville's first store)

Junction Hotel &
Rainier Saloon

Store

Turntable

fuel Plfm.

County Road
Roadway

◄— Bothell

The early business district was located on the hillside

A railroad turntable was located at the wye in Woodinville to allow early steam engines to be turned around. The railroad also placed a depot here in 1887, followed shortly by local businesses such as the Woodin-Sanders store, Rainier Saloon, and Junction Hotel. On the hillside opposite the tracks, the fledgling business community began expanding beside the road leading to Bothell.

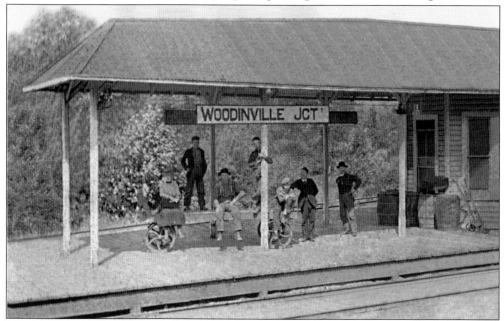

The Seattle, Lake Shore & Eastern Railway was launched in Seattle in 1885 and reached Woodinville in 1887. Here the railroad split, one line running north toward Snohomish and the other going south to Redmond and Issaquah. This junction platform, built between the two tracks about 1888, sheltered those waiting to board the daily train or meeting incoming passengers.

A new railroad depot was built in 1893 on pilings, just west of where railroad tracks separated to form a wye with one line heading north toward Snohomish and the other heading south toward Redmond. The depot's second story was clearly living quarters for depot agent Ed Harcourt and his family. Railroad workers (foreground) used a three-wheel velocipede track car to conduct track inspection and maintenance.

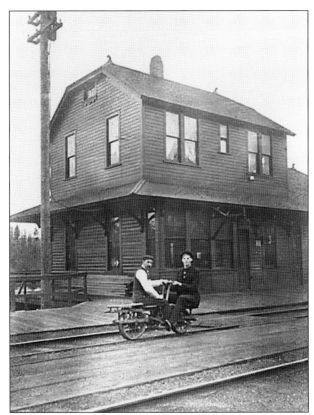

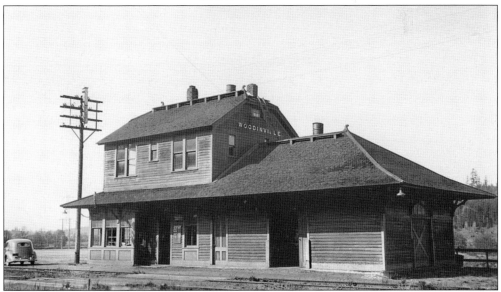

While most of its neighboring communities had one-story railroad depots, Woodinville's depot had a second floor, which originally provided living quarters for a depot agent. In this 1939 photograph, 55-gallon water barrels and a ladder can be seen on the roof in the event of a fire, which were not uncommon, as engine sparks from passing locomotives could easily ignite nearby structures. (Courtesy WSAPSB.)

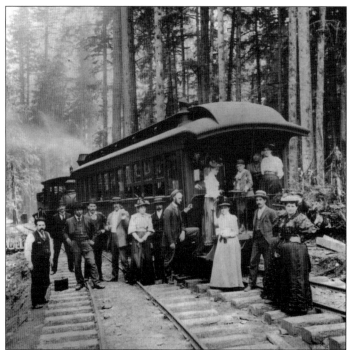

The Seattle, Lake Shore and Eastern Railway offered daily passenger and freight service for Woodinville. The line was established in 1885 by prominent Seattle businessmen, including Daniel Gilman and Judge Thomas Burke. The route ran from Smith Cove in Seattle around the north shore of Lake Washington. This photograph marks the day that service was inaugurated in Seattle. A portion of the rail bed has now become the Burke-Gilman Trail. (Courtesy MOHAI.)

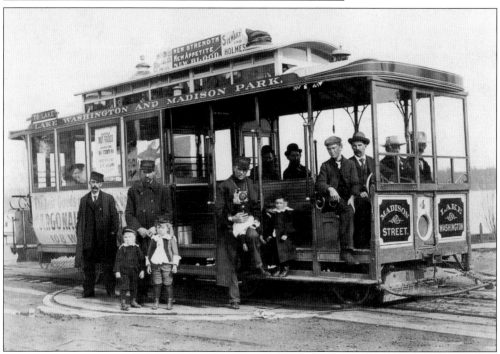

Woodinville residents often boarded Seattle's Lake Washington and Madison Park cable car after rowing down the Sammamish River and across Lake Washington, landing at Madison Park. Susan Woodin would take eggs and butter to sell in Seattle, walking from Madison Park to save money, sending the butter and eggs on the cable car. She would then retrieve the items in downtown Seattle to sell to customers. (Courtesy MOHAI.)

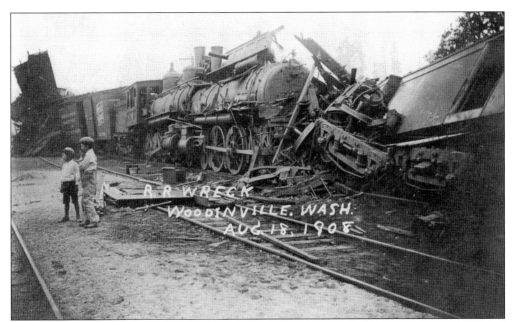

Children ponder the scene of Woodinville's famous train wreck of August 18, 1908, on northbound tracks near the current Woodinville Fire Station. A southbound passenger train crashed head-on into a northbound freight train, killing mail clerk Joseph Thompson and injuring engineer Albert Wishard, both of Seattle. Thompson, 39, left a wife and four children. Newspaper accounts said the mail car was shattered, and train passengers were bruised.

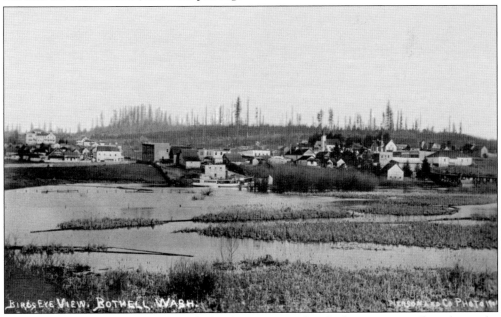

Melting snow in the mountains reached Lake Sammamish, which in turn overflowed into the Sammamish Slough. The Woodinville Valley then caught the excess as the slough rolled over its banks and covered local truck gardens. The resulting flood reached Bothell (pictured), stranding part of its populace on the opposite bank. Woodinville truck gardeners did not always mind the overflow, as the slough deposited silt that enriched their soil.

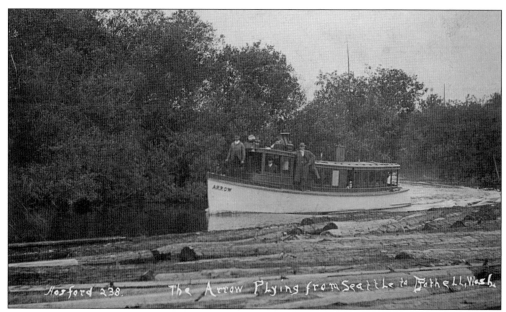

This 1910 postcard portrays the *Arrow*, one of several boats providing transportation and dodging debris up and down Squak Slough to serve Derby (Hollywood), Woodinville, Bothell, and Kenmore out to Lake Washington and across to Seattle. The boats made one round-trip daily. This speedy, steam-powered vessel was operated by Arthur and Fred Peterson, two of four enterprising brothers whose parents had homesteaded at Derby in 1876.

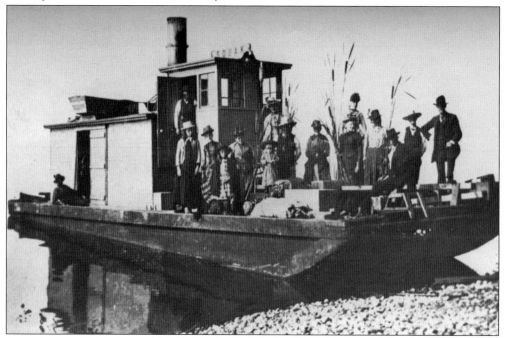

One of several flat-bottomed boats that navigated the Squak Slough in the late 1800s was the *Squak*. The slough was rife with sandbars and half-buried snags, requiring shallow-draft boats like the *Squak*, which drew only 2.6 feet and was driven by a 12-horsepower engine. The boats traveled regularly up the slough to Lake Sammamish, a trip taking 10 to 12 hours.

Flora Collicott Brown began driving her family's 1914 Model T when she was 12, taking her mother to Medina, with no driver's license needed. In 1909, six-year-old Flora had arrived in Woodinville from Montana with her parents. In this photograph from about 1919, she sits in the family car in front of the Parsons Hotel on Front Street, where brick paving had replaced the dirt road a few years earlier.

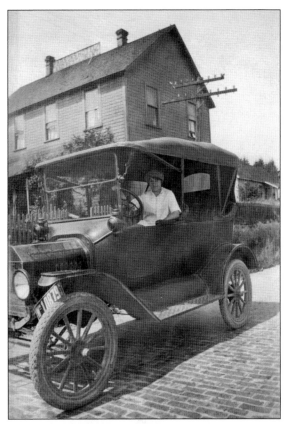

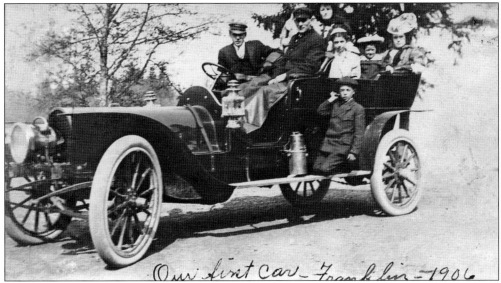

Frank Woodin, son of Woodinville's founding family, became the community's first car owner when he purchased this 1906 Franklin. The handsome car was large enough to carry his family, which might include his wife, Anna, and parents, Ira and Susan Woodin. Frank and his father had followed the gold rush trail to Alaska in 1899, returning the following summer. In 1901, Frank married Anna Peterson and began logging with his father-in-law.

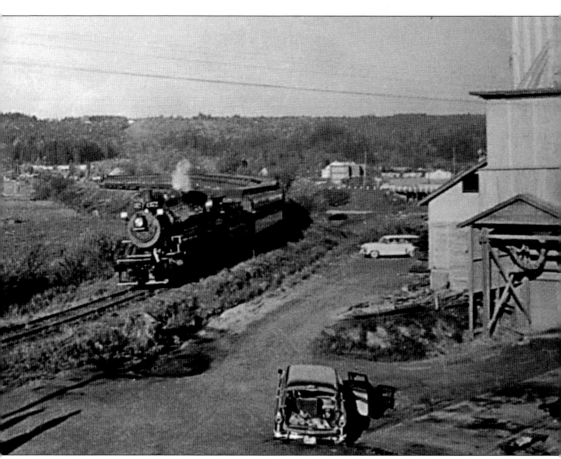

This 1957 photograph shows the *Casey Jones Special* excursion train turning around on the triangle at Woodinville for its return trip to Seattle via the Renton Belt Line. At far right is the DeYoung Feed Mill, which operated from 1946 to 1984. Visible in the background are the Woodinville School and gym as well as the Woodinville bridge over the Sammamish River.

Four

FERTILE VALLEY

After logging cleared the Sammamish Valley of its dense tree cover, people discovered the soil beside the river was fertile, as flooding over the years had deposited rich silt. By the late 1920s, immigrants claimed these lands and began turning large tracts into truck gardens.

These farms, operated by Fred Zante from the Philippines, Toshio Funai from Japan, and John Zanassi from Italy and his partners turned out lettuce, celery, cauliflower, and cabbage by the truckloads. These went to produce wholesalers or the Pike Place Market in Seattle, where the city shopped. Some of the produce ended up in train cars bound for the East Coast via the Canadian railroad system.

While these men worked tirelessly in the fields beside the river, other farming occupied the ends of the valley from the early 1900s. On the north was Millview Farm with its 50 registered Jersey cows producing milk for home delivery throughout the area. On the south was Hollywood Dairy Farm, equally productive with a herd of 100 Holsteins supplying milk, cheese, cottage cheese, and ice cream. These products not only fed home delivery routes but also supplied a farm store on the premises and a Seattle dairy shop and restaurant.

Poultry farming occupied the eastern hillside, where Hollywood Poultry Farm sold eggs and shipped its prize-winning leghorn chickens around the world. In pens atop Hollywood Hill were more than 1,000 laying hens pampered, analyzed in an onsite laboratory, fed special rations and hand-chopped kale, and bred for their egg-laying abilities.

Not to be outdone, others discovered the valley climate worked well for floriculture. Hollywood Gardens produced roses and carnations year-round in nine large greenhouses from 1912 until well into the 1930s. The flowers went to florist shops throughout the Northwest as well as to Alaska and Japan. A smaller greenhouse operation in downtown Woodinville expanded beyond all expectation beginning in 1956, and Molbak's became a household word in the Northwest and around the world.

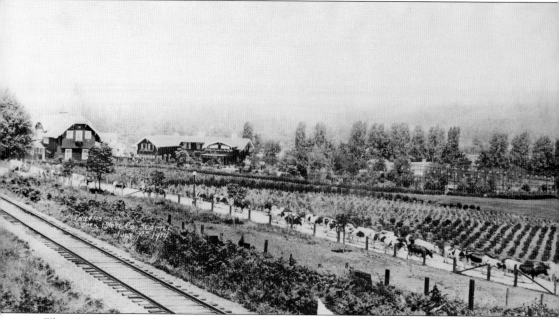

This 1914 panorama shows the sprawling Hollywood Farm of Seattle lumberman Frederick "Fred" Stimson. At left is Stimson's home with its carriage house and outbuildings. Moving along in the foreground are the farm's prize-winning Holsteins, heading past fledgling holly trees and a

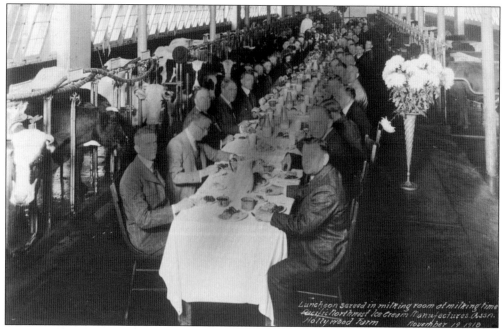

Cleanliness and sanitation were the order of the day at Hollywood (Dairy) Farm. The cows were scrubbed before milking, the barn floor was washed, and visitors were fumigated at the farm entrance. To highlight his modern methods, Stimson hosted this lunch on November 19, 1918, for the Pacific Northwest Ice Cream Manufacturers Association. (Courtesy UWLSC UW36367.)

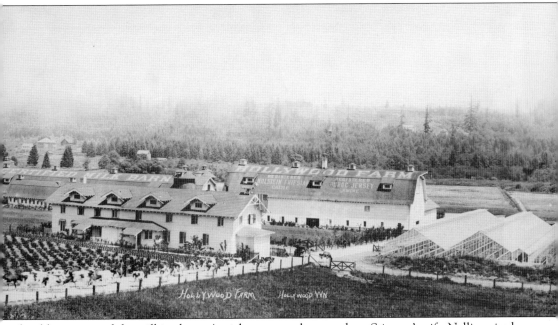

bunkhouse toward the milking barn. At right are greenhouses where Stimson's wife, Nellie, raised flowers for sale. In the distance is Hollywood Schoolhouse. Chateau Ste. Michelle winery has occupied the farm site since 1976.

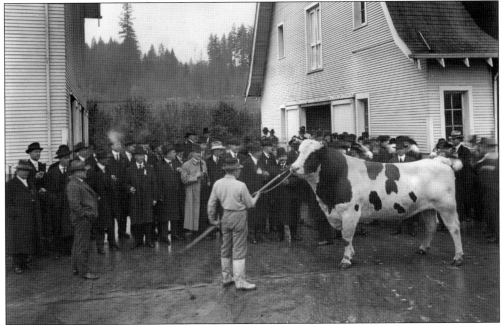

More than 50 members of the Pacific Northwest Ice Cream Manufacturers Association and guests gathered outside the milk barn, where they had lunch while seated among 100 Holstein cows. The focus here on this misty, cool day of November 19, 1918, was Stimson's prize bull, Judge Segis, the head sire for his prize-winning herd at Hollywood Dairy Farm. (Courtesy MOHAI.)

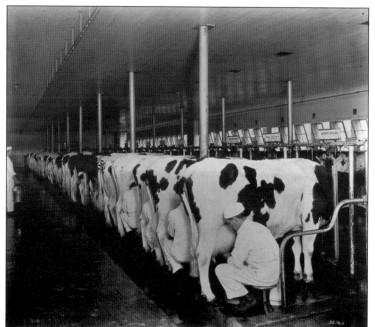

Milking time at Hollywood Farm was an orchestrated show of precision. White-garbed milkmen sat on their stools, milking the prime herd of 100 Holstein cows under pristine conditions. The cows were washed down daily, and the barn floor was scrubbed. Each cow had her own milking stanchion with her name above it. The resulting product was turned into bottled milk, cream, cheese, and ice cream.

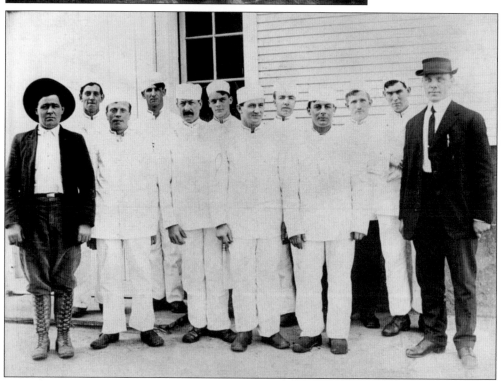

The immaculate attire of these milkmen was part of the regimen Fred Stimson established in operating his modern dairy farm in 1910. The men were required to change clothes twice daily before milking. Milk was handled under strict sanitation and bottled on the premises. Hollywood Farm sold its milk, butter, cheese, and ice cream on site and at Hollywood Store in downtown Seattle.

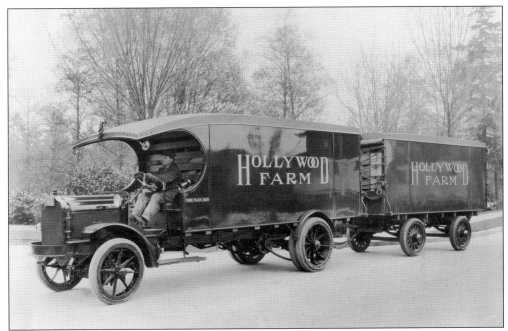

Hollywood Farm operated a fleet of delivery trucks between 1912 and 1922, ensuring that a variety of products from Fred Stimson's farms found their way to his store in downtown Seattle and individual customers. This truck and trailer could be carrying bottled milk, cheese, butter, or eggs from the Hollywood Poultry Farm. Roses and carnations from his wife's Hollywood Gardens also went to her floral shop in Seattle.

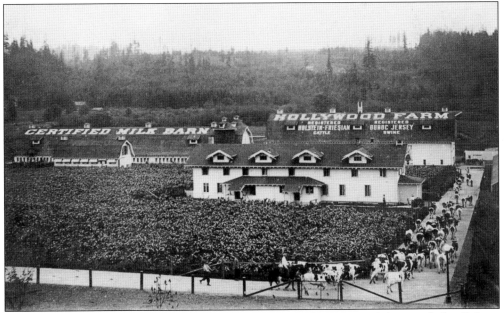

Hollywood Farm's herd of Holstein-Friesian cows are meandering toward the certified milk barn for their evening milking around 1912, tended by several farm workmen. The large building in the foreground is the farm bunkhouse. Beside the cows appears to be a field of young holly seedlings, which Stimson later used to line his driveway.

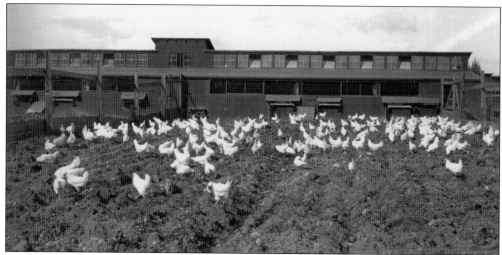

The nearly 200-acre Hollywood Poultry Farm featured spacious pens, special laying houses, and an onsite granary for hundreds of prized leghorn chickens bred by poultry man Morton Atkinson. In 1913, Atkinson had partnered his poultry expertise with Fred Stimson, who provided the financial support and property atop Hollywood Hill. The land has now become home sites, including an upscale development called the Farm.

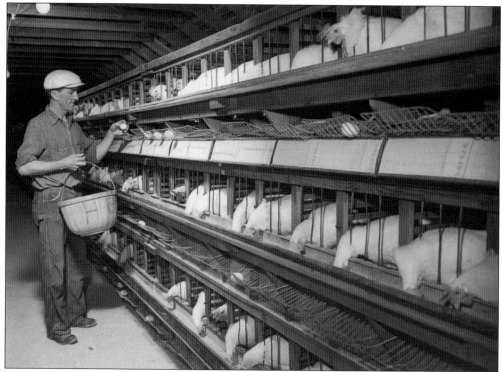

Frank Newland begins the daily task of gathering up to 7,000 eggs from Hollywood Poultry Farm's champion egg layers in 1935. Newspaper advertisements boasted that the Hollywood white leghorn was America's "greatest business chicken" because of its prodigious output. The eggs were available to local consumers and would-be farmers, as well as nationwide. The Hollywood strain continually brought home prizes in breeder competitions. (Courtesy MOHAI.)

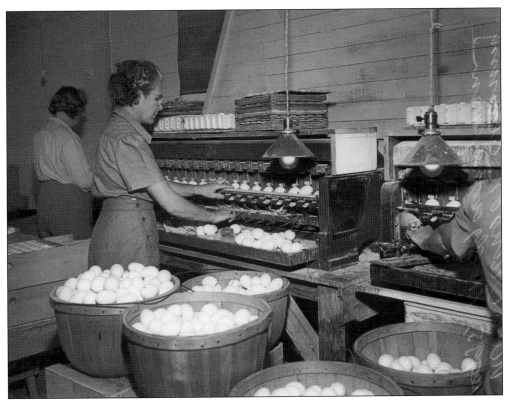

In this 1935 scene, a local woman carefully cleans the freshly gathered eggs. Morton Atkinson selected his breeding stock from top layers in New Zealand and Australia and soon attracted the attention of the poultry world with his Hollywood strain. The fertilized eggs were in high demand by poultry farmers across the country, and cases were routinely shipped from the local train depot to Asian ports. (Courtesy MOHAI.)

This 1900s farmer brought three generations of his family to the field to watch the threshing operation. Farmhands at the rear are redistributing the sheaves, and the belt-driven process is connected at far right to an adjunct operation. The fertile Squak (Sammamish) Valley was home to varied enterprises: dairies, beef cattle, truck gardens, hay, grain, hops, and even a golf course. The exact location of this scene is unknown.

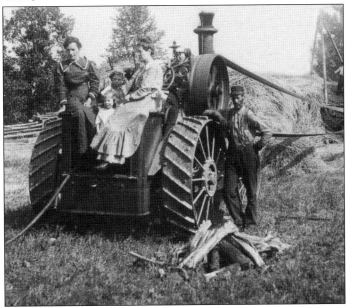

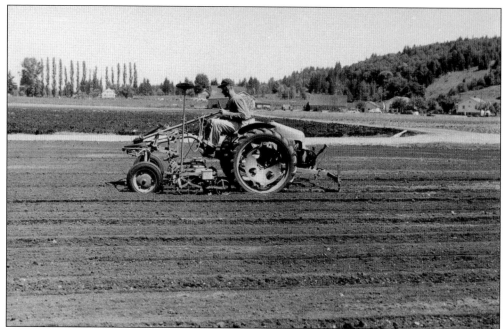

Edwin Zanassi watches that his tractor is spanning the rows of carrots evenly at the Zanassi truck farm in the valley south of Woodinville in 1955. The farm was founded in 1922 by Edwin's grandfather Tony Zanassi and then bought by Edwin's father, John Zanassi, several years later. In the background is the former Vincent Kaelin house (at left) and barn (behind tractor), both still standing.

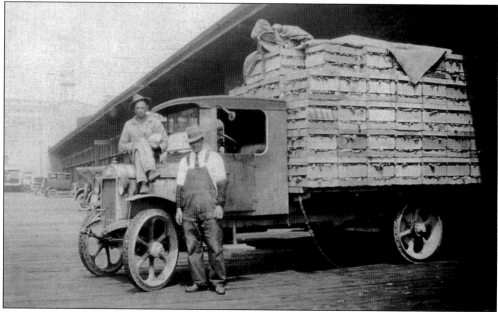

Pictured here around 1920, truck gardener John Zanassi (right) stands beside a GMC truck loaded with lettuce he has brought to a Seattle wholesaler. Behind him is Louis Segalli, one of his partners. When John acquired the Sammamish Valley farm in the 1920s from his immigrant father, Tony, he also took in six partners to form J. Zanassi and Company. Before long, the company was shipping 200 crates of lettuce by train daily.

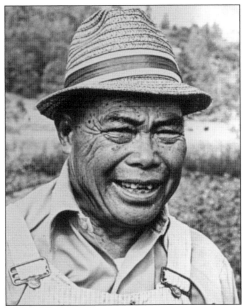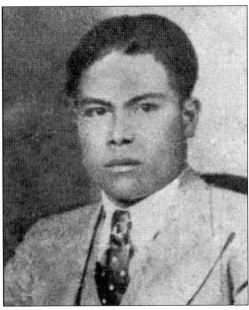

Fred Zante was one of several farmers who tilled the fertile Sammamish Valley for decades. Emigrating in 1924 at the age of 18 (right) from the Philippines to California, he moved to Woodinville in 1927 and acquired acreage. Returning to the Philippines in 1952 to marry his wife, Dorie, he continued growing produce for Seattle markets while Dorie tended their roadside stand. Widowed now, Dorie lives on a farm surrounded by the city.

Tony Vitulli (far right) shows a produce buyer some of the fine celery growing on his valley farm while Herman Delvecchio (white shirt) directs three workers. The farm began with Italian immigrant Tony Zanassi, who bought 26 acres in 1922. His son John purchased the farm and formed J. Zanassi and Company, taking in partners like Baranzini, Vitulli, Poggi, Pignataro, Delvecchio, and Miller.

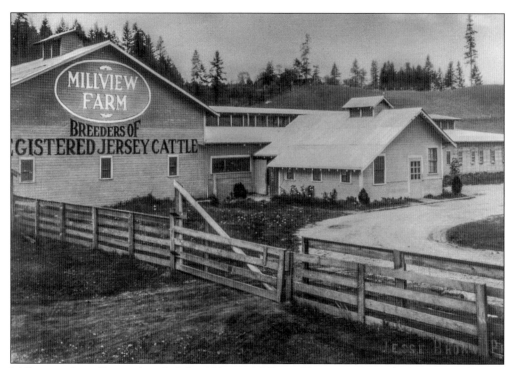

Mill owner Jesse Brown founded the 100-acre Millview Farm in 1924 with 50 registered Jersey cows. Brown's son Ben ran the milk house and his son-in-law Nels Rongve delivered the milk to Seattle homes. A separate barn held 300 tons of hay. The advertisement below appeared in a special edition of the *Bothell Sentinel* newspaper in 1924, promoting the farm's purebred Jersey dairy cows. Brown's grandson Stephen "Bus" Brown bought the dairy around 1950, continuing operation until the state of Washington bought the farm in 1959 to extend State Route 522 and create the 132nd Avenue NE interchange.

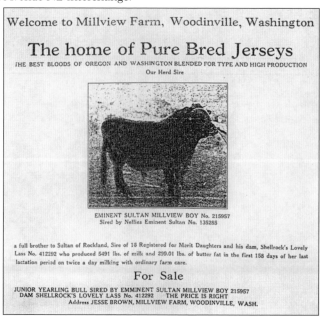

Welcome to Millview Farm, Woodinville, Washington

The home of Pure Bred Jerseys

THE BEST BLOODS OF OREGON AND WASHINGTON BLENDED FOR TYPE AND HIGH PRODUCTION
Our Herd Sire

EMINENT SULTAN MILLVIEW BOY No. 215957
Sired by Nellies Eminent Sultan No. 135285

a full brother to Sultan of Rockland, Sire of 16 Registered for Merit Daughters and his dam, Shellrock's Lovely Lass No. 412292 who produced 5491 lbs. of milk and 299.01 lbs. of butter fat in the first 158 days of her last lactation period on twice a day milking with ordinary farm care.

For Sale

JUNIOR YEARLING BULL SIRED BY EMMINENT SULTAN MILLVIEW BOY 215957
DAM SHELLROCK'S LOVELY LASS No. 412292 THE PRICE IS RIGHT
Address JESSE BROWN, MILLVIEW FARM, WOODINVILLE, WASH.

Five

BUSINESS AND INDUSTRY

Woodinville's population in the late 1800s relied mainly on the industry of logging and lumber mills. But as trees and underbrush were cleared away and railroads began offering daily train service, new arrivals also discovered the rich soil lying on both sides of the river.

Sprawling truck gardens, greenhouses, and dairy farms lent a bucolic look to the landscape. The community even boasted a nine-hole golf course and a thriving brickyard. These occupations and businesses required support services, leading to general stores, blacksmith shops, restaurants, saloons, meat markets, and as many as five hotels during the early 1900s. The stores inevitably became gathering places for the scattered population to socialize and catch up on the latest news.

The advent of electricity in 1910 literally lighted up the business and residential community, and the arrival of automobiles brought service stations and auto repair shops. Farm stores appeared on the scene to support the agricultural industry. Businesses like Clara Teegarden's Shop and DeYoung's Woodinville Mercantile carried their customers on credit into the Great Depression of the 1930s, holding families together.

Unique businesses that appealed to a specialized clientele included two enterprises on the Woodinville-Duvall Road—Dickerson's Bee Farm and Cunningham's Swan Farm. Elizabeth Dickerson sold jars of honey and homemade jams from her roadside shop for years as well as contracting with a Seattle department store. The swan farm at the Avondale intersection featured a large manmade pond with dozens of white and black swans sold to avian aficionados.

When I-405 was constructed along Woodinville's western edge, suburbia came to the peaceful valley and brought hundreds of new residents. Zoning for light industry attracted companies dealing in specialized engineering, refrigeration components, oil refining, and fishery products. Within a few years, Molbak's Greenhouse became an internationally known nursery, Vintage Auto Parts drew inquiries from around the world, and Chateau Ste. Michelle and Haviland Winery foreshadowed Woodinville's wine tourism of today.

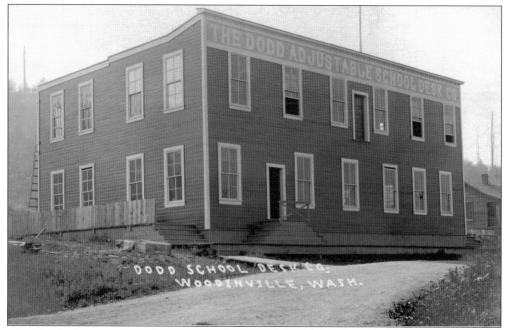

This 1907 building on Front Street housed the Dodd Adjustable School Desk Factory. The business was founded by W.T. Dodd, who had arrived in 1906 to teach at Woodinville School but did not finish the term as a result of student heckling and a disagreement with the school directors. Dodd had designed a desk with adjustable heights to accommodate various student sizes, and sold stock to finance his enterprise. (Courtesy UWLSC UW25665z.)

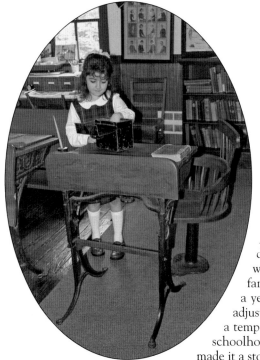

A sample from the adjustable desk factory is displayed at the Woodinville Heritage Museum, where Gracie, a descendent of the pioneer Woodin family, inspects it. Dodd went bankrupt within a year, partly because the metal needed for the adjustable parts was too costly. The factory became a temporary school in 1908–1909 when the wooden schoolhouse burned down. Later, the Ruelle brothers made it a store and social hall.

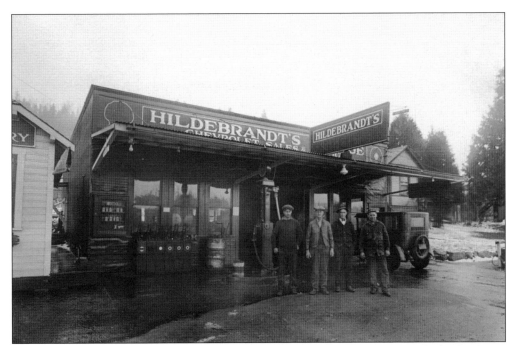

Around 1922, Edgar Hildebrandt operated a garage on Front Street after he and Charles Green had opened Bothell's first auto repair shop in 1913. Hildebrandt had also briefly partnered in a Ford franchise at Bothell with the Anderson brothers. By 1927, he was specializing in Chevrolets at his Woodinville site. The men standing in front of the 1927 Chevrolet Capital Coach are unidentified except for Frank Lucas, second from left.

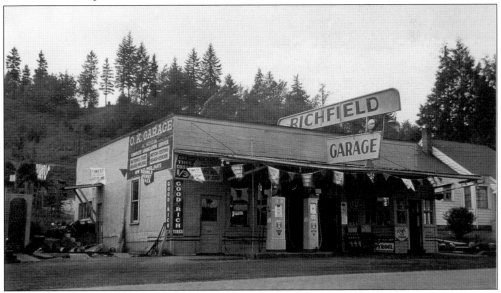

The OK Garage and Richfield service station stood along what was Front Street when it was built in 1922. In this 1939 photograph, the garage business owned by Al Morgan offers full lubrication service, auto parts, and tires. Lydia McDonald owned the site and the house next door at right. Roy McDonald originally operated the service station, and ice cream, candy, and tobacco were also available there. (Courtesy WSAPSB.)

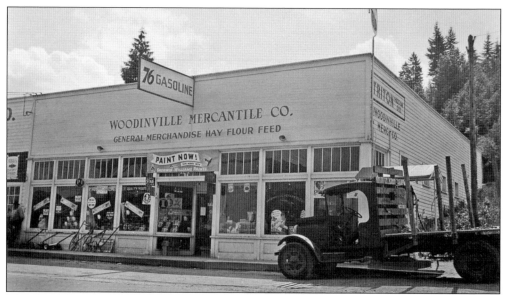

John DeYoung moved his family north from Kent in 1925 when he heard about a business opportunity in Woodinville. In 1927, he built Woodinville Mercantile on Front Street, having purchased the contents of Clara Teegarden's store when she sold her shop. In this 1939 photograph of his store, lawn mowers and garden tools sit in front, and a Union 76 gas pump anchors the corner behind the truck. (Courtesy WSAPSB.)

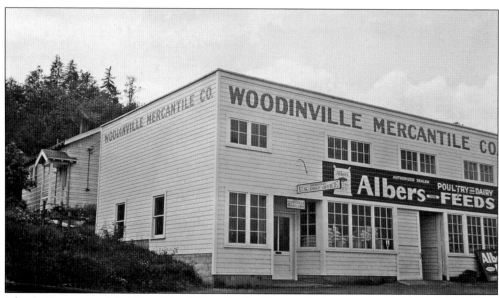

John DeYoung expanded his original Woodinville Mercantile business by doubling the length of his structure in 1939. The new section housed hardware and poultry and dairy feeds, plus a post office on the south end. The original 1927 section to the north carried a variety of staples and groceries. Woodinville Mercantile also contained frozen food lockers, as home freezers had not arrived in households yet. (Courtesy WSAPSB.)

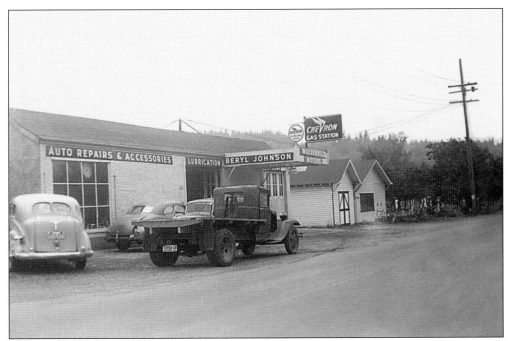

Beryl Johnson operated Woodinville Motors on Woodinville's main street for nearly 40 years. He bought the garage just west of Woodinville School in 1946, two years before this photograph, and expanded the building over time. When NE 175th Street was widened in the early 1980s, Johnson found it difficult to operate the business with limited vehicle access and subsequently closed the garage.

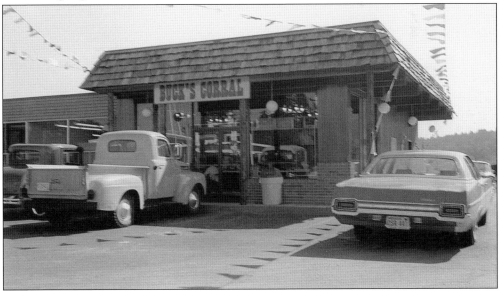

Buck's Corral was considered to be Woodinville's first fast-food restaurant, opening in late 1971 adjacent to Woodinville's 1960 post office building on the corner of NE 175th Street and 130th Avenue NE. Subsequent names of the café were Charlie Brown's Pantry and, in early 1977, Grubstake Charlie's. The site is now the northwest corner of the Woodinville ball fields. (Courtesy WSAPSB.)

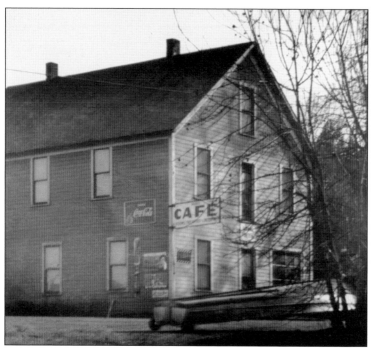

In 1903, Boyd and Pearle Hargus moved to Woodinville, where they built a home and opened Boyd's Place as a café. By 1910, they had expanded into the Hargus Hotel with seven rooms and a main-floor restaurant serving daily meals. This photograph from about 1956 advertises George's Café and offers rooms. The building was demolished in 1961. Beside it was a tavern, replaced later by McCorry's on the Slough. (Courtesy WSAPSB.)

This 1939 photograph shows the rental units and cabins available behind the Hargus Hotel operated by Boyd and Pearle Hargus. The units were rented by local loggers and railroad workers of the day. The cabins were available at least three decades earlier, as evidenced by an article in the February 5, 1910, *Bothell Sentinel* newspaper that notes, "Mr. Knoll and family moved into one of Mr. Hargus's houses across from Mr. Ruelle's store." (Courtesy WSAPSB.)

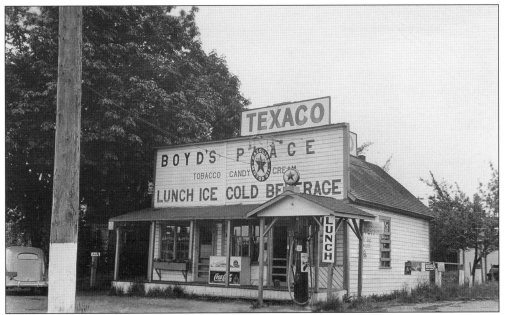

In 1903, Boyd and Pearle Hargus opened Boyd's Place southwest of their Hargus Hotel and rental cabins by the slough bridge in Woodinville. Originally, the business sold assorted groceries and lunches. Once automobiles appeared, a Texaco gas pump was installed in front, sheltered by its own roof. In this 1939 photograph, an air station has appeared to the left of the porch for the convenience of local motorists with soft tires. (Courtesy WSAPSB.)

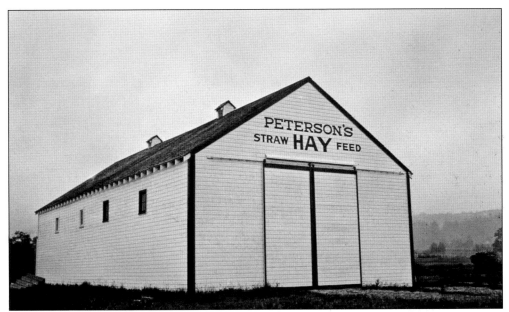

In the mid-20th century, Arnie Peterson's giant storage barn for straw, hay, and feed was a familiar sight in the business district. A small store (not shown) stood in front at street side, where customers would pay for their merchandise, then pull around to the rear to load up at the barn. The business stood on the north side of today's NE 175th Street, probably about 135th Avenue NE. (Courtesy WSAPSB.)

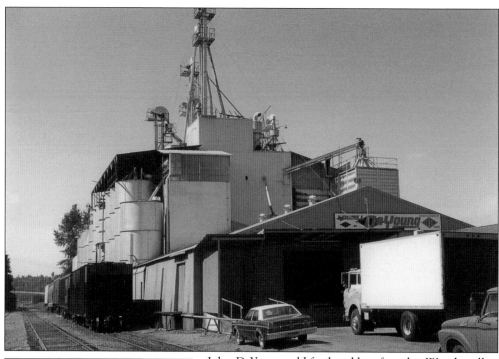

FOR POULTRY PROFITS

FEED DECO GROWING MASH

Deco Growing Mash is a balanced growing feed containing animal and vegetable proteins with Animal Protein Factor added to insure proper development of your pullets.

All Deco poultry feeds contain only the highest quality ingredients with Animal Protein Factor added.

★

Lowell DeYoung Company

Woodinville Phone 2491

COMPLETE FEED AND FUEL SERVICE

John DeYoung sold feed and hay from his Woodinville Mercantile store location on Front Street for nearly two decades. In 1944, his son Lowell took over the feed operation and moved it across the street to a former produce-shipping warehouse on the north side of the railroad tracks. Two years later, the company installed a mixer grinder and began manufacturing its own feed products under the Deco label. The advertisement at left shows how the company's chicken mash was marketed to poultry owners.

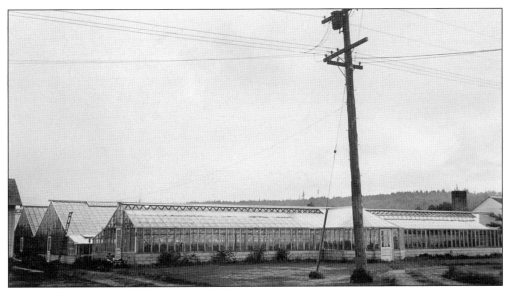

Ashley Nicholas erected five greenhouses on NE 175th Street in 1934 after dismantling them at his first location north of Bothell. He moved his family into an adjacent bungalow, barely visible at left in this 1939 photograph. Known as Ashley's Flowers, the business was sold in 1956 to Egon and Laina Molbak. (Courtesy WSAPSB.)

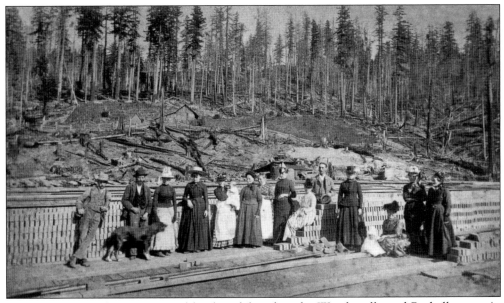

This 1900s scene depicts a typical brickyard found in the Woodinville and Bothell areas. At Woodinville, Superior Brick and Tile Company was founded in 1908 by George Shaw at the present-day intersection of Brickyard Road and Woodinville Drive. The company, employing up to 40 men, produced vitrified brick for the Green Lake Trunk Sewer, among other projects. Shaw built his brick home west of the brickyard, and it is still there.

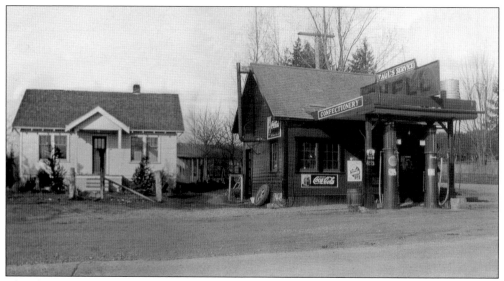

This downtown corner has served motorists since the 1920s, beginning with Gillespie Service Station, followed by Chet and Chet (Fosberg and Ormbrek) in 1928, and Paul's Service Station and Confectionery until 1934. Walter Gibbs bought the station in 1935. The final owner employed onsite manager Lou Pineo, a familiar figure during the 1960s. An auto parts store has since replaced the station.

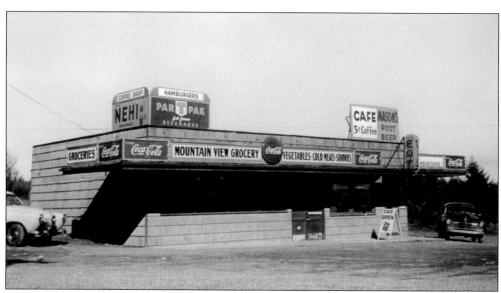

Claude Hinman and Glen Yeamans opened Mountain View Grocery on the summit above Woodinville in the 1940s. The Hinmans had arrived in 1938, and Claude commuted to his job in the Bremerton Shipyards while Yeamans ran the store. Their wives operated a nearby coffee shop until Hinman bought out Yeamans. Hinman helped organize Summit Fire Department in 1947 and donated adjacent land for the first stationhouse in 1950.

Six

COMMUNITY FABRIC

Woodinville developed as a settlement, but it also became a community. Homesteaders welcomed newcomers, and together they created churches, schools, activities, and recreation.

Ira and Susan Woodin opened their home to the first school session, a 12-week term taught by Charles Dunlap in 1881 for nine pupils ranging from age five to 14. Dunlap received $25 for his efforts, conducting daily recitations in reading, penmanship, spelling, and arithmetic.

Gustav Jacobsen built a log school on his homestead around 1888, farther south along Squak Slough. By 1892, a one-room schoolhouse emerged on land donated by the Calkins family. The same site housed three subsequent schoolhouses, including today's brick building. Nearby schoolhouses sprouted from 1890 onward, usually to serve logging camp families in Cottage Lake, Derby (Hollywood), Bear Creek, Grace, and Paradise Lake.

The Woodin parlor also hosted the first church service, conducted by a Bothell minister around 1880. Other families offered their homes for the next 20 years until Woodinville built a Methodist church across from the schoolhouse in 1905. A second denomination, Cottage Lake Presbyterian Church, emerged in the 1940s.

Families traveled to Bothell for the annual Fourth of July parade, returning for a community picnic beside the slough. The Foresters' Lodge, housing an organization of logging and mill workers, hosted dances and box socials, as did a hall at Derby and the Woodinville schoolhouse

By 1886, Woodinville boasted a population of 60, and mail was delivered twice a week. After the railroad arrived in 1887, the community was linked with Seattle and beyond. Guy Funk's Cherry Valley Stage carried passengers daily from 1906 to 1908 between the Woodinville railroad depot and the Valley House in Duvall, following a wooded trail that eventually became the Woodinville–Cottage Lake Road. Frank Smith was the stagecoach driver.

By 1910, electricity was extended from Bothell, and telephones became available. Several families purchased automobiles, and the community began moving beyond the slough and valley.

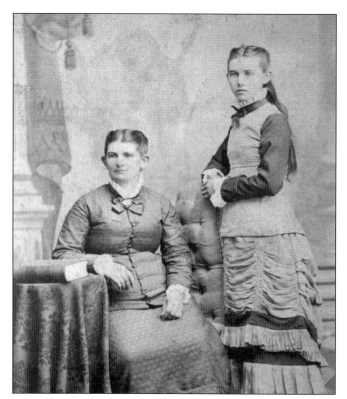

Susan Woodin and her daughter Mary adopt the solemn pose expected in early portraits, but the Woodins normally were a lively group. Ira and Susan had left Seattle in 1871 with their daughters, ages four and seven, to stake out a homestead in the wilderness up Squak Slough. Their home became a halfway stop for travelers between Seattle and the upriver settlements and served as the local post office for nine years.

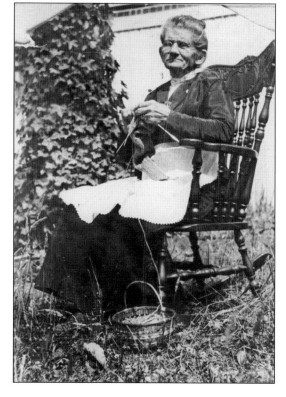

Susan Campbell Woodin was born in Oregon in 1848. Pioneer children learned to do their part for the family, so by the age of five, Susan was knitting and had completed one pair of socks. Thereafter, she was expected to knit one sock a day. A year later, she was doing the family washing. Susan was already an accomplished homemaker at 15 when she married 30-year-old Ira Woodin in 1863.

Woodinville's two-room schoolhouse was built in 1902, replacing a one-room structure built in 1892 and moved to the rear, where it eventually became the boys' and girls' restrooms after serving as teacher housing. In this 1905 photograph, teachers Marion Bemis and William O. Farmer stand at left rear with their pupils, including the boxers on the porch. A few look almost old enough to be teachers themselves.

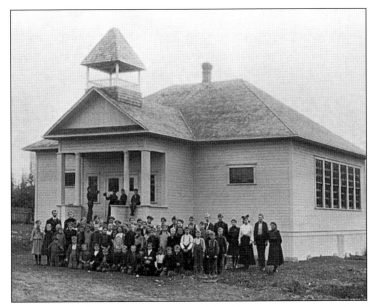

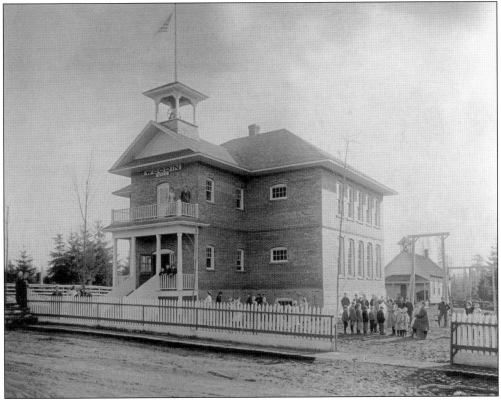

This brick school was the third built on the downtown school site, opening in early 1910. It was the first brick school east of Lake Washington and replaced a wooden one that burned down in 1908. This one had four classrooms, and a balconied principal's office overlooked the entry. Electricity was coming to Woodinville, but the school still had no indoor plumbing. The original 1892 school (at rear) served as a teacher's dwelling.

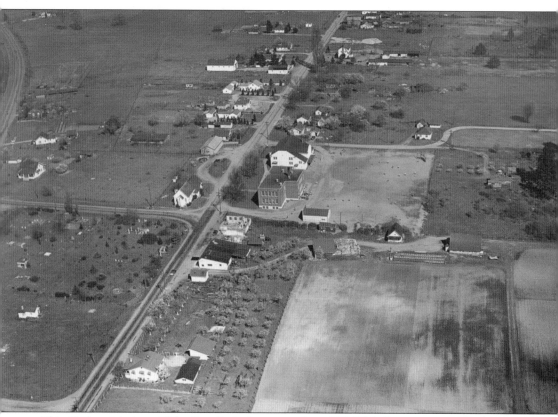

This 1946 aerial view of Woodinville looking east shows NE 175th Street running up the center, with a tilled field (lower right) where the community ball fields now exist. At the intersection in the foreground is the Woodinville Cemetery (northwest corner), Woodinville Methodist Church (northeast corner), Woodinville Motors (southwest corner), and Woodinville School and white gym (southeast corner). Continuing east are mostly residences.

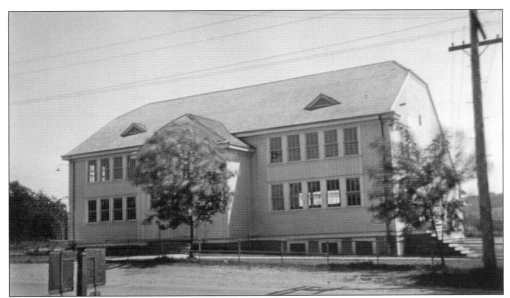

As Woodinville's school population grew after World War I, the school board authorized construction of a gymnasium east of the brick school in 1923. The frame building, shown here in 1939, provided space for rainy-day recreation, games, dances, and community activities. The basement later housed a woodshop, cafeteria, kitchen, and small library augmented weekly by a King County mobile unit. The building was demolished in the 1960s. (Courtesy WSAPSB.)

Classmates happily pose in 1950 behind Woodinville School (left rear) and the white school gymnasium (center), while other schoolmates enjoy recess in the sunshine. The school gym, built in 1923, also provided the community space for events and meetings, and a small library served by a King County bookmobile. The frame building was demolished in the 1960s, but the brick schoolhouse remains and is designated a City of Woodinville landmark.

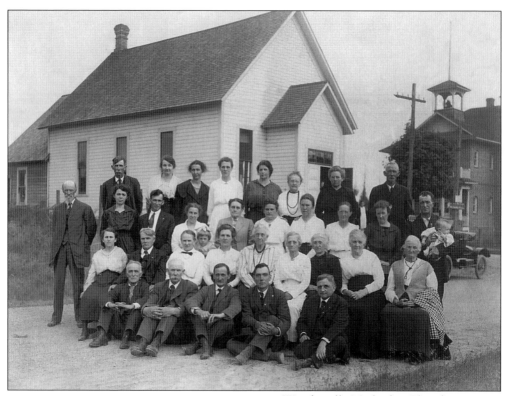

WOODINVILLE SCHOOL NEWS

VOL. 1 WOODINVILLE, THURSDAY, MARCH 17, 1910 NO. 1

To the Public, GREETINGS:

This is our first public appearance. We feel somewhat bashful under your critical eye, for we are aware of our many failings.

Our object in coming before you is to awaken an interest in the school and to give ourselves some training in practical business.

We find many lessons learned in school are hard to remember, because we cannot use them in practice and so we forget them. We believe that the managing of this small paper will give us some of this practice.

We will publish each week, all items of interest from the school and we trust you will be interested enough to give us the financial support so necessary to carry on the work.

If the practice received here, saves your boy or girl from making one mistake in after life, your money will have been well invested.

Yours truly,
The Staff.

THE SCHOOL-HOUSE STEPS. -

Only some kids in the moonlight,
 Only some kids 'twould seem,
Only some kids on the school-
 house steps.
 Indulging in loves sweet dream.

Only the stars were looking,
 Only the new moon knew
Whether their hearts were fickle
 Whether their hearts were true.

The soft night air was laden
 With love's most longing sighs
When man's eyes looked in maid-
 en's
 And glimpsed of Paradise.

WOODINVILLE ITEMS.

We were all glad to see Mrs. Jacobson in town Sunday.

Misses Marguerite and Agnes Hansen, visited Bothell Sunday.

Mrs. Hinch is visiting her daughter at Monroe.

A number of the Bothell young folks were in town Sunday.

Miss Nolle visited Mrs. Olson, Tuesday afternoon.

(Cont'd on Page Four.)

Woodinville Methodist Church got an early start, using the Woodin family parlor in the 1870s with an itinerant minister. Ototake Yamoka, who headed the Oriental Trading Company in Seattle, donated part of his Woodinville property in 1905, and a church was erected for $1,000. The congregation is pictured here in 1917 when the church still relied on three outhouses, kerosene lantern lighting, and wood stove heating.

Publishing the news of their Woodinville School as a student project was just as relevant in 1910 as it is in modern schools, and this chatty edition even included a poem and some town news, too. This March 17 edition was the first school newspaper published after the new brick school opened on Woodinville's main street in early 1910. The previous wood-frame school had burned down in late 1908.

When children gathered in the fall of 1906 for their obligatory school photograph, the students ranged from the barefoot boy in the front row to more formally garbed eighth graders at rear. The two-room schoolhouse had been built in 1902 but burned down in 1908, when the classroom stove overheated. Teachers in the photograph are Gertrude Maylor (front right) and W.T. Dodd (upper left), who left mid-term.

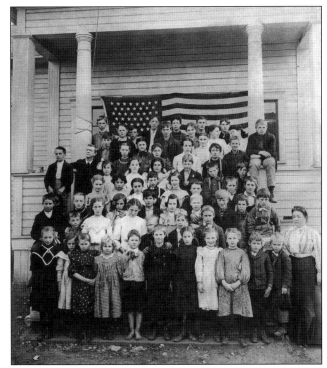

Woodinville resident Al Mack (holding the reins) prepares to participate in Bothell's Fourth of July Parade with an unidentified friend in 1905. The Bothell parade was a tradition from the early 1900s. Participants and spectators also came from surrounding communities such as Woodinville and Derby. Woodinville residents would then return to their picnic grounds beside the slough bridge for a community gathering followed by fireworks at night.

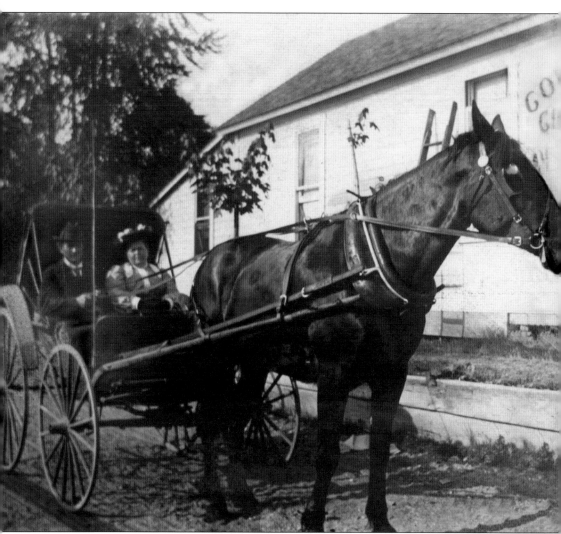

William and Anna Smith are ready for an afternoon jaunt with their new trotting horse and cart. The Smiths and their son Frank came to Woodinville in 1904. Smith had been a logger but began operating a meat market near the river bridge, and his wife opened a restaurant next door. Smith got his meats from Frye Packing Company in Seattle, shipped daily on the morning train.

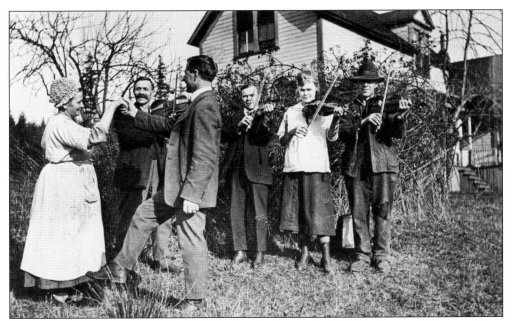

The Gilbert Ormbreks lived on the hill above where today's 140th Avenue NE meets State Route 9. Practicing a dance step in the front yard of their home are, from left to right, Carrie Ormbrek, husband Gilbert Ormbrek with his fiddle, Carrie's partner and brother-in-law Olaf Ormbrek, unidentified, the Ormbreks' daughter Gudrun, and unidentified. The Ormbrek barn was a spacious site for community dances.

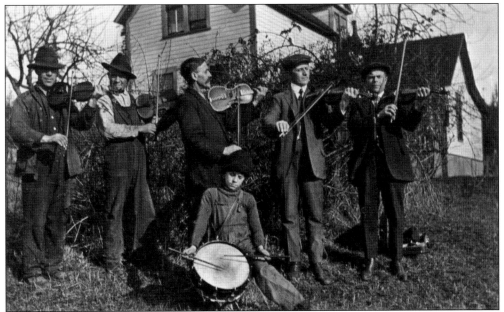

Musicians rehearse in the yard of Gilbert and Carrie Ormbrek around 1920, where they would play for dances in Ormbrek's new barn. As many as 80 local residents would attend the lively events and dance until dawn. The musicians are tentatively identified as Gilbert Ormbrek, center, facing his brother Olaf Ormbrek. Gilbert's son John is the young drummer. The other three fiddlers are not identified.

The home of pioneer Elmer Carlberg (standing in front) until his death in 1984 was a picturesque landmark for many years along the west side of the Sammamish Valley. The Scandinavian American–style house with its distinctive turret and later embellishments was built in 1887–1888 by his parents, John and Julia Carlberg, on land originally homesteaded by Julia Carlberg's father, Andrew Anderson, in 1880. The structure was dismantled in the 1990s.

After arriving from Kansas, John and Mary Durham built this spacious home around 1890 on the hill overlooking Bear Creek, south of today's Woodinville High School. The Durhams had five children, Dorothy, Lillian, Celia, Thomas, and Eva. Two additional homes were built on the property and occupied by family members. The original home's last occupant was a widowed daughter, Celia Waugh. The house was demolished in the 1970s.

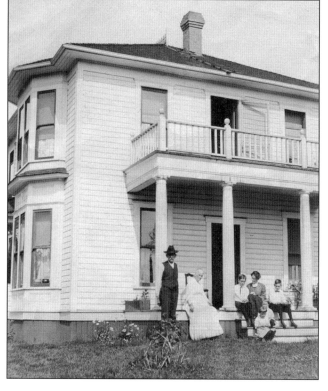

Jacob and Mary Butler sit on the porch of a house immediately above Front Street sometime between 1912 and 1921. The Butlers had moved to Woodinville from Indiana to be near their daughter Cora and her husband, Frank Lucas, in 1912. Lucas operated a confectionery store on Front Street, adjacent to Hildebrandt's Garage.

Andrew and Amanda Hinch lived at Avondale and Cottage Lake before coming to Woodinville in 1897, where they raised four daughters, Arland, Daisy, Antle, and Annie. Their house was a popular gathering place. These family members are unidentified but may include some Hinch daughters. The property on the northeast corner of NE 175th Street and 140th Avenue NE later housed Ace Sanderlin's family and his Woodinville Rodeo.

This Dutch Colonial home was built in 1931 on Woodinville's main street for John and Ellen DeYoung and their six children. The family came to Woodinville from Kent in 1925, and DeYoung established Woodinville Mercantile on Front Street. The 10-room house originated from a design Ellen DeYoung found in a home magazine. Moved in 1973 to NE 171st Street, the building now houses the Woodinville Heritage Museum.

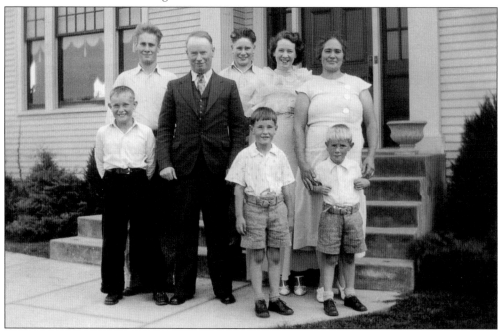

The John DeYoung family stands in front of their Dutch Colonial house around 1935. The house's location on NE 175th Street was convenient to DeYoung's Woodinville Mercantile business at the west end of the street. From left to right are (first row) Robert, John, James, and Al; (second row) Milford, Lowell, Anna Frances, and Ellen.

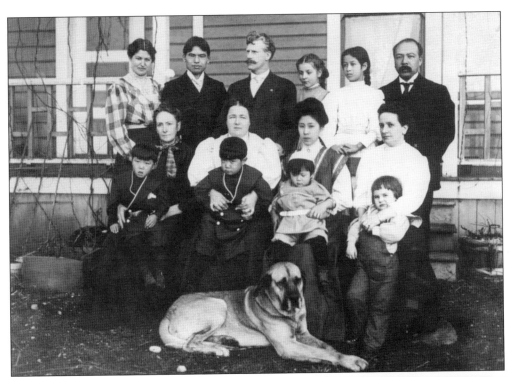

Woodinville residents gather at the Ototake Yamoka home across the road from the cemetery around 1907. From left to right are (first row) Susan West, Elsie Myers, Mrs. Yamoka, and Lilian Harcount, wife of depot agent Ed Harcourt; (second row) two unidentified, teacher Warren Dutton, the young Rita Harcourt, unidentified, and Ototake Yamoka. The other youngsters may be Yamokas.

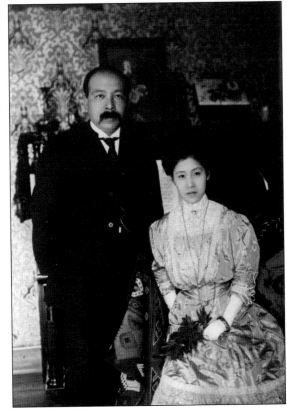

The Ototake Yamokas arrived in Woodinville around 1901. Their large white house east of the cemetery had been a home for troubled women run by the Methodist Episcopal Church of Queen Anne in Seattle on land homesteaded in 1880 by L.P. Larson. Yamoka operated the Oriental Trading Company in Seattle, and it was said he had trained in medicine at university level. The Yamokas provided some of their land for the first Woodinville church in 1905.

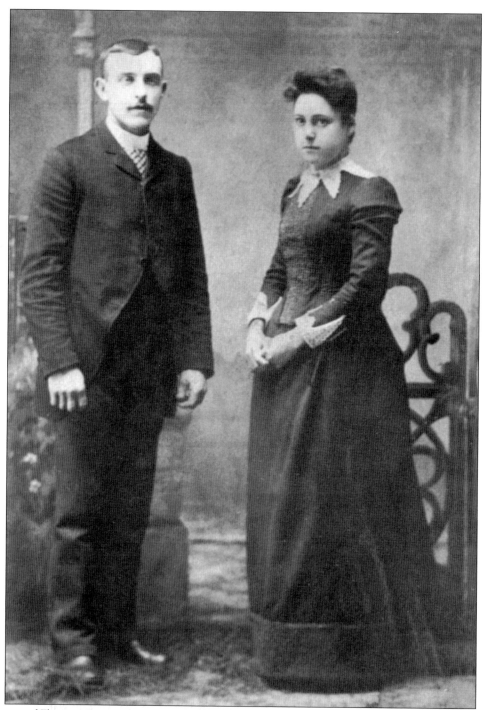

Jesse and Florence Brown were married in 1890 and moved to Woodinville in 1909. Brown operated the Woodinville Lumber Company at Grace and later the Machias Mill in Woodinville. The Browns lived in a home on the hillside overlooking the mill. About 1925, Jesse started Millview Dairy with 50 Jersey cows and home delivery of milk. The dairy land is now part of State Route 522 and the Woodinville exit ramp.

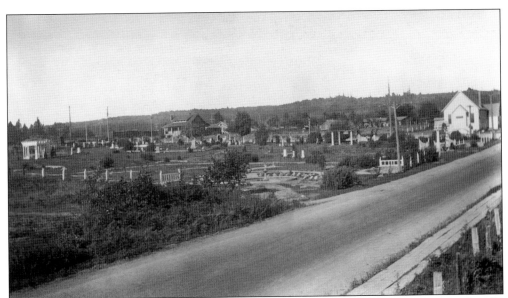

Woodinville Recessional Memorial Mead in the 1930s was the forerunner of today's Woodinville Cemetery, still featuring the white pergola at left. The Woodin family donated one acre in 1889 for the cemetery after two little girls died of diphtheria in 1888 and were buried here. In the background are the Woodinville Methodist Church (right) and the Ashley Holden home (left). At lower right is the wooden boardwalk used by schoolchildren.

Billy and Gertie Jaderholm pose with their children prior to World War I. In 1881, Billy was born in Woodinville to Mary B. Neilsen and early logger Eric Jaderholm, who died in a logging accident not long after Billy's birth. His mother later married carpenter Anders Hansen. Billy's early employment included working at his grandparents' store and serving as Woodinville's first mail carrier.

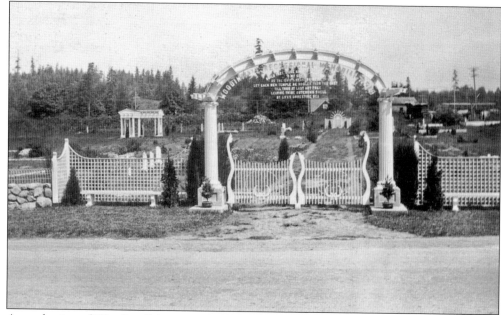

An early view of Woodinville's cemetery on NE 175th Street shows the original fence, columns, and gate surrounding the one-acre tract donated by the Ira Woodin family in 1889. The sign above the gate reads, "Woodinville Recessional Memorial Mead: O my soul / as the swift seasons roll / let each temple be nobler than the last / till thou at last art free / leaving thine outgrown shell / by lifes unresting sea."

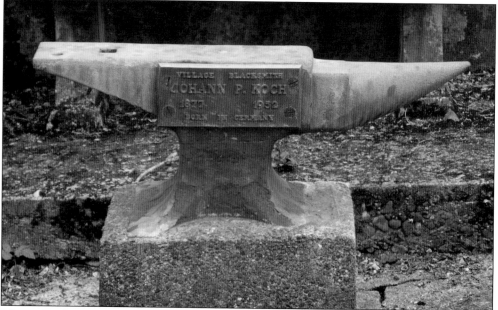

Johann Koch's anvil served him well as village blacksmith and became his headstone in the Woodinville cemetery at his 1952 burial. Born in Baden-Baden, Germany, in 1877, Koch immigrated early to America and even anglicized his name to John Cook when hostility toward Germany peaked during World War I. Moving from Front Street during World War I, he opened his shop across from the cemetery.

Seven

RECREATION

When families in Woodinville found leisure time, there was no shortage of recreation available in the 19th and 20th centuries. Five lakes and a river offered swimming, boating, and picnic opportunities. Dancing and socializing occurred in homes and halls.

The Woodinville Literary Society, Lake Leota Community Club, Woodinville Improvement Club, Foresters of America, Modern Woodmen, Woodinville Social Club, Sammamish Valley Grange, and Mountain View Improvement Club were formed by people with a fraternal purpose or civic plan.

Barn dances at the Ormbrek home east of Woodinville, live music by the Donnergaard family at a hall above the Derby store, and dances at Ruelle's hall beside the Woodinville bridge lightened the lives of pioneers. Crystal Lake Lodge brought lake residents together for picnics, dances, and dinners at its spacious clubhouse. Even the Woodinville PTA provided social activities.

Touring minstrel shows appeared in Woodinville periodically, including Daddy Draper's Orphan Band. Local men played on the Hollywood and Woodinville community baseball teams from 1910 to 1920. One of the teams was said to have won the state amateur championship in 1911 and again in 1912.

Resorts on Cottage Lake, Summit Lake (Leota), and Paradise Lake drew visitors from the Seattle area as well as local residents. Cottage Lake offered four different resorts at various times, culminating in Norm's Resort. The Sammamish River drew boat racing every April under the auspices of the Seattle Outboard Association. Spectators lined the 13 miles of riverbank from Kenmore to Redmond to watch speeding boats navigate the twisting bends of the river.

In 1960, Seattle pet food manufacturer William Tyrrell founded Gold Creek Park south of Woodinville. The recreational complex offered swimming, ice skating, and picnicking along with a narrow-gauge train, sternwheeler boat, pioneer fort, and gristmill. In 1969, the park property changed ownership and hosted a three-day rock festival. Entertainers included Ike and Tina Turner, Led Zeppelin, Paul Revere and the Raiders, and Chuck Berry.

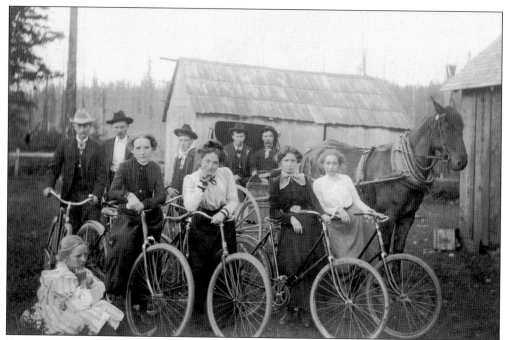

Four Donnergaard sisters and their companions are poised in the early 1900s for a bicycle excursion, while one of their younger siblings watches. The horse and wagon provided alternate transport around the family farm, located on today's Hollywood Hill. In the 1890s, Hans and Martine Donnergaard had homesteaded on the hilltop, where they raised six daughters and a foster son.

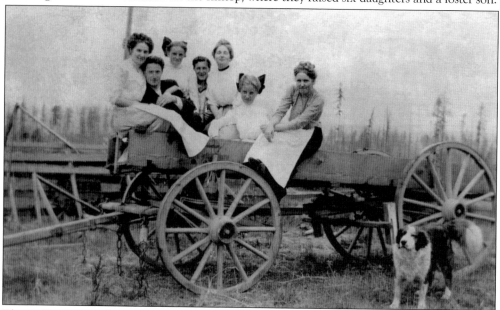

The six Donnergaard sisters and their foster brother, Irving Krumm, are ready for a wagon ride on the Derby hilltop farm owned by their Danish parents, Hans and Martine, around 1900. Four girls, Esther, Gertrude, Dagne, and Irene, were born in Denmark before Donnergaard's political ideas forced him to leave for America in 1891. After his family joined him later, two more daughters, Lalla and Fanny, were born.

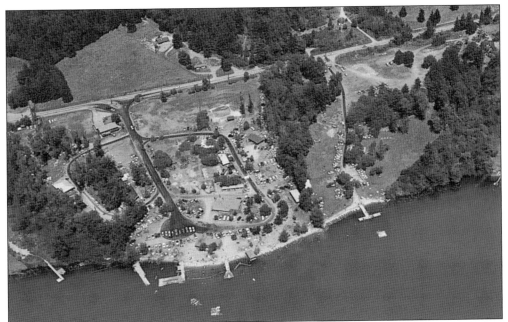

Norm's Resort sprawled along the Cottage Lake shoreline in the 1960s. The famous resort had ample space for family and group picnics, games, boat rentals, swimming, a café, and a dance pavilion. In the 1940s, Norm and Georgianna Fragner had combined Erickson's Lake Resort, owned by Gus and Fay Erickson, and Bob and Ray's Resort, operated by Bob DeYoung and Ray Braga. Access was via the Woodinville-Duvall Road.

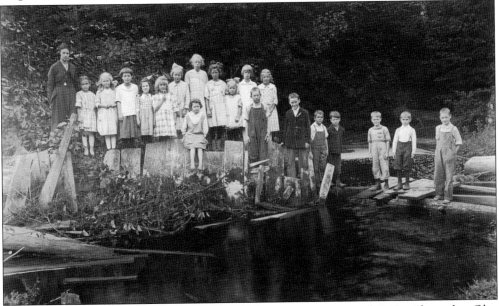

Children from Cottage Lake School are pictured on an outing around 1919 with teacher Olga Anderson (upper left). The setting was possibly Bear Creek near Cottage Lake and may have been chosen by famous photographer Darius Kinsey, as he arranged the children on the creek bank and bridge. The only children identified are the teacher's nephew Russ Rogers (fourth from right) and his friend in overalls beside him, Stan Jacklin.

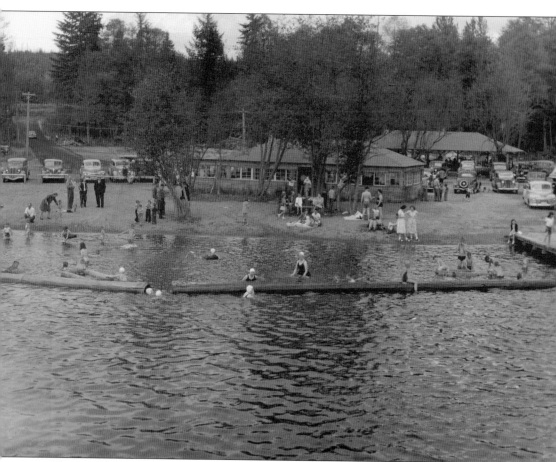

This 1940s scene shows Norm's Resort on Cottage Lake, where visitors could swim, picnic, rent boats, eat at the café, and dance to live music. The resort was operated by Norm and Georgianna Fragner, who consolidated two others, Erickson's Lake Resort and Bob and Ray's. Norm's Resort became familiar across the country through a simple marketing device—Fragner persuaded visitors to carry away a fish-shaped sign and mount it somewhere.

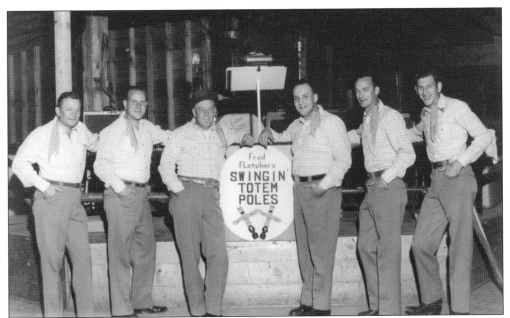

Norm's Resort on Cottage Lake offered picnicking, swimming, dancing, boat rentals, and lawn games. Special picnics often attracted more than 5,000 attendees. This 1958 photograph depicts Fred Fletcher's Swingin' Totem Poles ready to play for dancing. Norm's Resort ran from 1942 to 1979 until owner Norm Fragner's death. American Adventures operated the facility until 1989 as a members-only RV park. The facility has been a King County park since 1992.

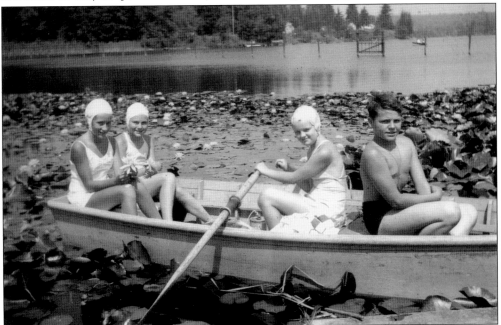

Enjoying a summer day on Cottage Lake around 1945 are Sally Wilwerding (second from left) and her brother Joe (right) with their family friends Natalie (left) and Pony, among a field of lily pads. In the distance is a fence strung from shore to shore to separate the rest of the lake from this section owned by Ezra Jurey, whose 1890 homestead granted him a portion of the lake.

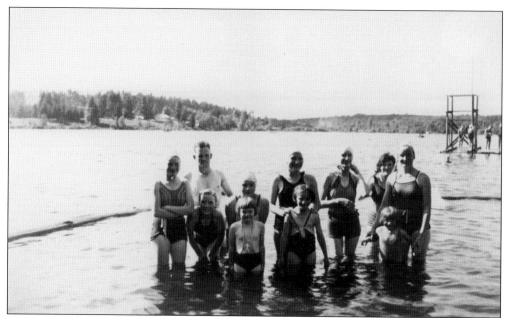

These youngsters and parents are enjoying Cottage Lake's warm summer waters at Camp Comfort in 1939. This site was one of the day-use resorts that offered picnic grounds and a swimming beach for the pleasure of residents and vacationers. A family named Miller owned Camp Comfort, which later became Cedar Grove Resort. It stood on the southeast shore where the Cottage Lake Beach Club development is now located.

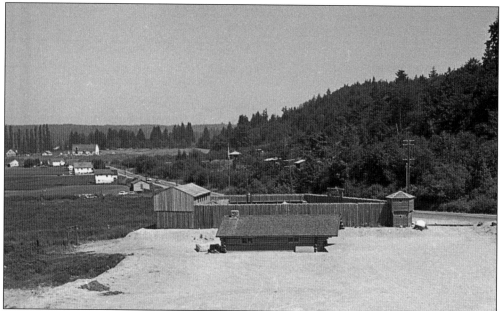

Anchoring the north corner of William Tyrrell's Gold Creek Park was an authentic Western fort made of logs assembled by a skilled Canadian woodsman. The fort contained a barracks building at rear with a kitchen on the ground floor. An upper walkway connected the two guard posts. Outside the fort walls was the trading post, used by local groups for meetings. Gold Creek Park drew thousands each summer.

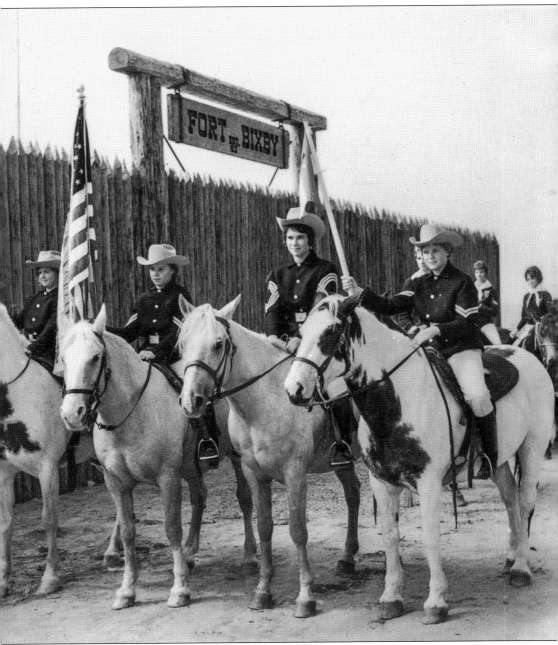

Four Gold Creek Cavalry members prepare to ride as color guard during the dedication of Fort Bixby in 1963. Pictured are, from left to right, Mary Cameron, Sharon Nelson, Patty Gintz, and Ann Dykstra. The authentic fort was built by a Canadian woodsman brought to Woodinville by Gold Creek Park developer William Tyrrell. Inside were a kitchen, officers' quarters, and bunkhouse.

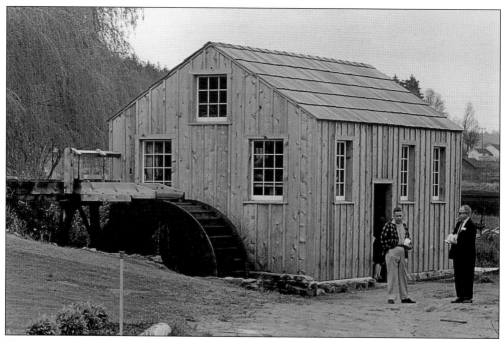

This authentic grist mill with 200-year-old grinding stones from Georgia was one of several ideas Seattle pet food manufacturer William Tyrrell had when he created Gold Creek Park south of Woodinville in the 1960s. The mill was built in 1962 and regularly ground Montana hard wheat into flour, from which the Park staff made Gold Creek Brownies. The park hosted local families as well as corporate picnics. (Courtesy MOHAI.)

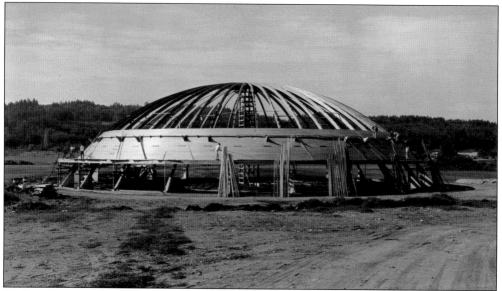

Under construction in early 1964 was the Ice Dome at Gold Creek Park, which hosted large-scale skating shows and offered lessons and recreational ice skating. The opening show featured world-class skaters Ron and Cynthia Kaufman, Lorna Dyer, and John Carroll. The instructor for skating lessons was Canadian national champion Marsha Deen. The Dome also had heated spectator seating and a small café. (Courtesy MOHAI.)

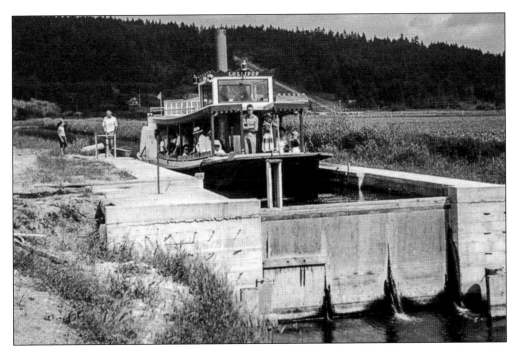

Gold Creek Park developer William Tyrrell wanted children to enjoy his 74-acre enterprise, so he had an authentic sternwheeler built in 1962 and christened it the *Lollipop*. His employees dug a channel called the Peppermint River, adding a set of locks so the boat could navigate safely along the channel and out to the larger Sammamish River before returning to its landing at Fort Bixby.

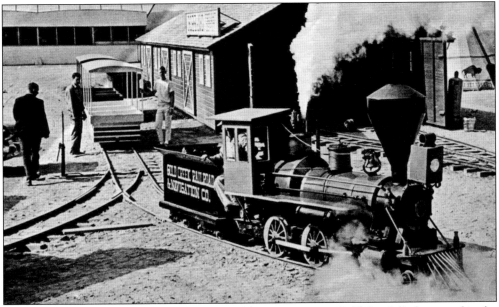

An operating narrow-gauge railroad was one of the attractions at Gold Creek Park, created in the 1960s by Seattle pet food manufacturer William Tyrrell to provide family entertainment for the Greater Seattle area. Open-air cars behind the engine carried children around part of the 74-acre park perimeter, often with Tyrrell himself at the controls. The *Diamond Stack* was an authentic Civil War–era engine, delighting railroad aficionados.

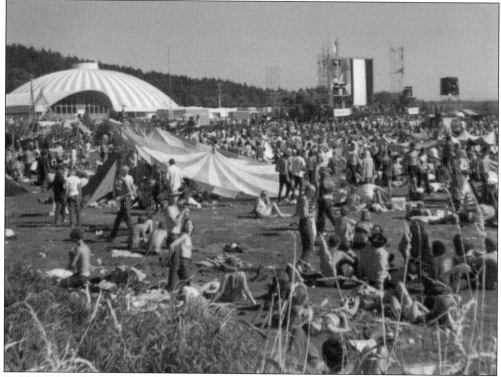

Gold Creek Park, created in the early 1960s by William Tyrrell, was sold in 1969 to Gold Creek Associates, represented by Charles Dawsey. He staged what was billed as the Seattle Pop Festival on the park grounds the last weekend of July 1969. Thousands of fans gathered to hear the likes of Chicago Transit Authority, Ike and Tina Turner, Chuck Berry, Paul Revere and the Raiders, and Led Zeppelin.

The John Fruhling family raised Appaloosa horses during the mid-20th century on their ranch near Woodinville. They often appeared at horse shows and parades in costumes reminiscent of the Plains Indians. In this photograph, John Fruhling, foreground, and family members are preparing to stage a mock raid during the dedication of Fort Bixby. The fort was one of the attractions at Gold Creek Park in Woodinville during the 1960s.

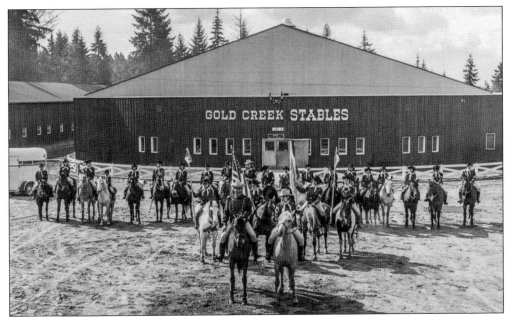

Local youths formed the Gold Creek Cavalry in 1962 and drilled under direction of former US Army cavalryman George Cooper. Practicing at Gold Creek Stables every Saturday, the precision unit appeared at local parades and events during the 1960s. Wearing Civil War–style uniforms sewn by mothers and using authentic McClellan army saddles, they even defended nearby Fort Bixby during a mock raid by Appaloosa Club members costumed as Indians.

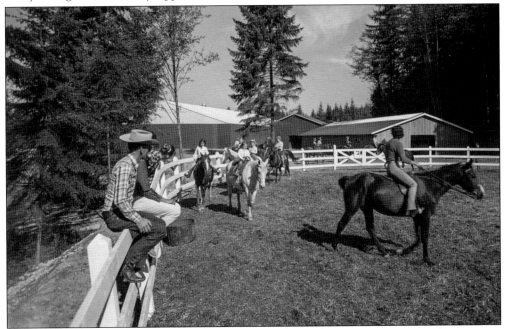

This outdoor arena serves Gold Greek Stables (rear) more than 50 years after its construction atop Hollywood Hill in 1961. Still popular with riders of all ages, Gold Creek Stables offers riding lessons and an indoor arena with spectator seating for 500. The facility was part of Gold Creek Park, a sprawling recreational complex founded by pet food manufacturer William Tyrrell.

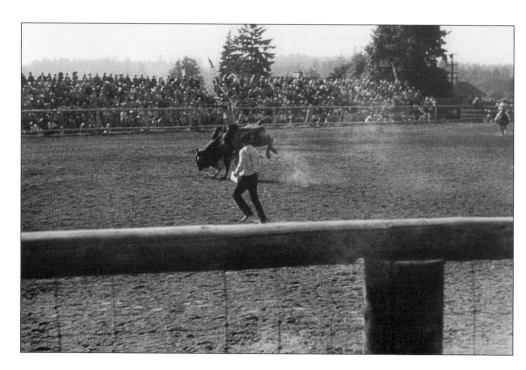

Former King County sheriff's deputy Ace Sanderlin operated the popular Woodinville Rodeo from 1949 to 1961. The rodeo grounds at NE 175th Street and 140th Avenue NE drew top names among rodeo riders who toured the annual circuit from Canada to Mexico. Sanderlin had bought the former Andrew Hinch home for his family, and his arena encompassed today's park-and-ride lot. These views look northwest past the spectator seating.

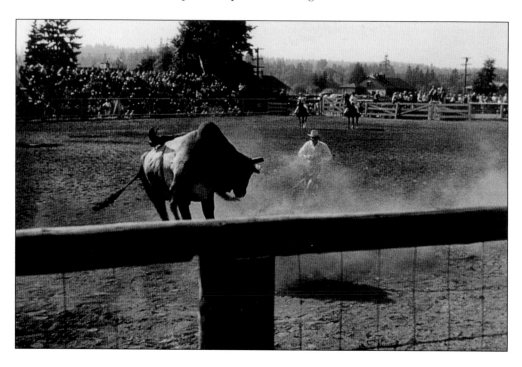

The April running of the Sammamish Slough Race from Lake Washington to Lake Sammamish was a popular spectator event for nearly 50 years. Up to 40,000 viewers lined the banks, cheering as limited hydroplane drivers dodged bridge pilings, jumped sunken logs, and occasionally beached as they roared through 63 turns along the 13-mile course. The races began in 1933 and ended in 1976 because permitting and insurance costs had escalated.

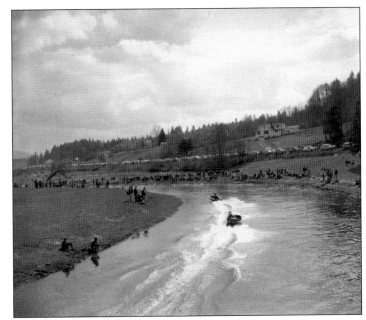

This hunting lodge was a rustic retreat for Hollywood Farm owner Fred Stimson, owned by his lumberman brother C.D. Stimson of Seattle, who also had a poultry and pigeon farm in Kirkland. Fred Stimson (second from left) is pictured here around 1905 with fellow hunters, who often spent several days here hunting and birding. The lodge, called the Willows, was in the Sammamish Valley near today's NE 124th Street.

The Hollywood Baseball Club was sponsored by Hollywood Farm owner Frederick Stimson and said to be the champions among state amateur teams in 1911. A small stadium built by Stimson apparently stood at the Hollywood intersection, diagonally across from the schoolhouse. Pictured here are, from left to right, (first row) Hollywood Farm storekeeper Al Green and four unidentified players; (second row) catcher Russell Snyder and batboy Arthur Carlson; (third row) Frank Ness, Charles Walters, pitcher Bert Woodruff, coach Cliff Christianson, and Roland Campbell. Standing at rear is scorekeeper Elmer Carlberg. Some of these players may have been itinerant mill or farm workers, as they do not appear by name in local censuses.

Eight

NEARBY SETTLEMENTS

As Woodinville approached the 20th century, it may have been the shopping center for early settlers living in a 10-mile radius, but outlying clusters of people were already forming their own settlements.

Cottage Lake and Paradise Lake to the east initially drew loggers and lumber camps. These in turn necessitated schoolhouses as early as 1890. A daily stagecoach connected the area with Woodinville and thus Seattle via railroad. Enterprising residents established lakeshore resorts in the 1920s, and a few stores opened nearby to serve visitors.

The community of Derby in the valley south of Woodinville had a school by 1892, and resourceful settlers like Caroline Peterson and Andrew Lunn operated restaurants and stores for their own neighbors as well as travelers aboard the passenger boats that plied Squak Slough before 1908. A few years later, Frederick Stimson's Hollywood Farms attracted dozens of employees. Stimson renamed the area Hollywood, having planted a row of holly trees along his winding driveway.

North of Woodinville was Grace, an early train stop with its own general store, school, and shingle mill. The settlement sat astride the King-Snohomish County line and offered services to those living at Bear Creek to the north, Maltby to the northeast, and Wellington on the nearby ridge.

Although electricity was extended to Woodinville in 1910, power lines were slower to reach these satellite communities. Likewise, telephone service was tardier. In fact, Derby-Hollywood residents formed their own Hollywood Telephone Company in 1911. They invited a representative of Pacific Telephone Company from Bothell, who advised them that five subscribers were a minimum, and 10 subscribers would be better.

Potential users were told to erect their own poles and splice into the Sunset line running from Bothell to Redmond. They were assessed 10¢ annually for each pole and $5 for each phone, plus the cost of supplies and equipment. Eventually, Hollywood residents voted to sell their line to Pacific Telephone in 1929.

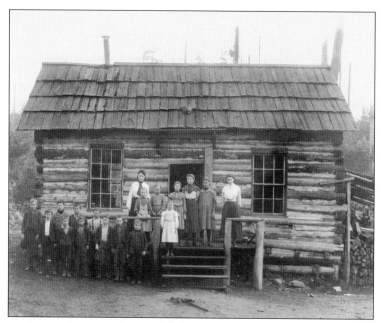

The first Cottage Lake School was a rough-hewn log cabin built in a forested clearing in 1891, possibly on the west side of Cottage Lake. This photograph is dated 1905 and shows teacher Gladys Gillette with most of her 23 students. The lean-to contained wood for the stove, a nearby well provided drinking water, and a hitching rail in front served riders. The school was also a community gathering place.

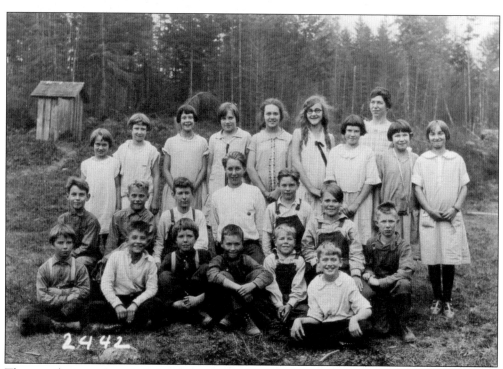

These smiling pupils and their teacher, Mary Sharpe, upper right, are among those attending Cottage Lake School around 1922. The schoolhouse, built in 1905 on Campbell Logging Company land, was located east of today's Avondale intersection near the Reintree entrance. Several pioneer families are represented in this group, including Newberg, Freeman, Erickson, and Mack. The monthly teacher salary was $130. Cottage Lake consolidated with Woodinville School District in 1931.

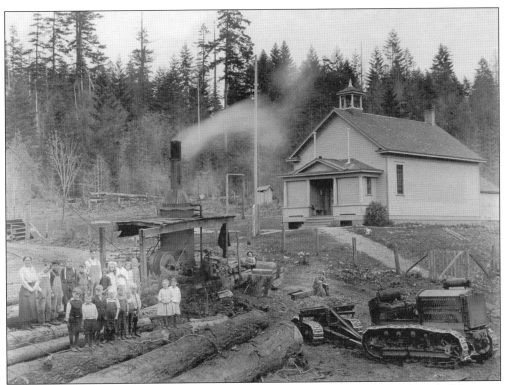

Fay Erickson and her Cottage Lake pupils shared their schoolyard with the Campbell Logging Company. Erickson taught over the whine of saws and roar of the donkey engine. An outhouse can be seen in the background. The engine operator leaning back in his seat was Charlie Mann, and the unidentified bulldozer operator sits nearby. Cottage Lake consolidated with Woodinville School District in 1931, and this 1905 school ceased operation in 1934. The enlarged section below brings the pupils and Erickson into closer focus as they perch on logs harvested by Campbell Company loggers, soon to be sawed into lumber.

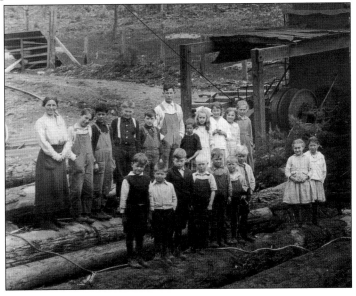

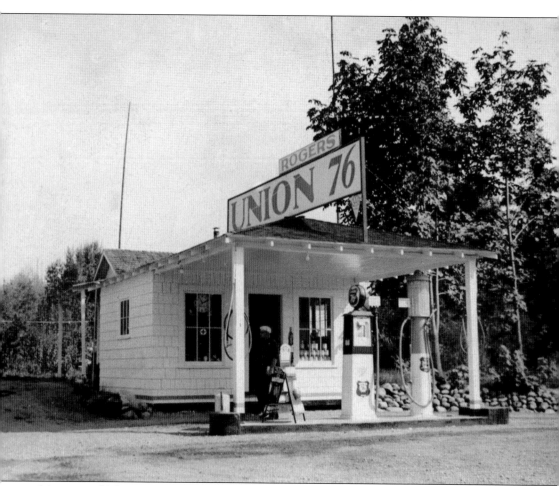

Manson and Marie Rogers opened a Union 76 station across from Cottage Lake in 1934, serving local residents and lake resort traffic along the graveled Woodinville-Duvall Road. Russ (a nephew) and Ursie Rogers bought the station in 1946, and while Russ worked another job elsewhere, Ursie often pumped gas. The location continues to serve auto traffic as a repair shop, and the lake resort is now a King County park.

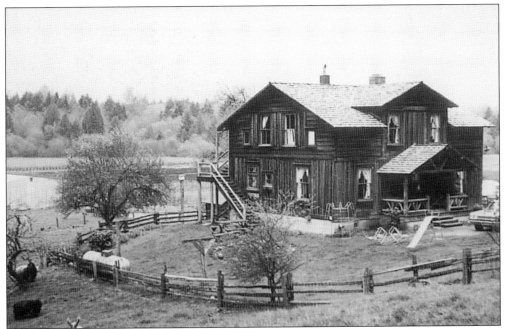

This house, designated a King County landmark, was built at the north edge of Cottage Lake around 1896 by N.E. Nelson on 146 acres that had been homesteaded by Moses Lovee in 1883. Successive owners were the Parker family, C.A. Shinstrom, Howard and Hope Munn (who operated a blueberry farm there for 25 years), and Martin Howard. Paul and Judy Thomas bought the house in 1971 and restored it.

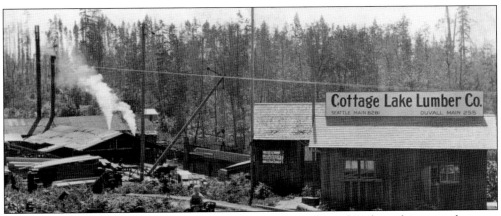

Cottage Lake Lumber Company operated in the Cottage Lake and Redmond areas, with camps in several locations and mills in Woodinville, Bothell, and Duvall in 1924–1926. The company relocated to Renton in 1929 and renamed itself Renton Mill Company in 1936. The company maintained a lumberyard in Redmond from 1924 to 1938, which ultimately became Redmond Lumber Incorporated.

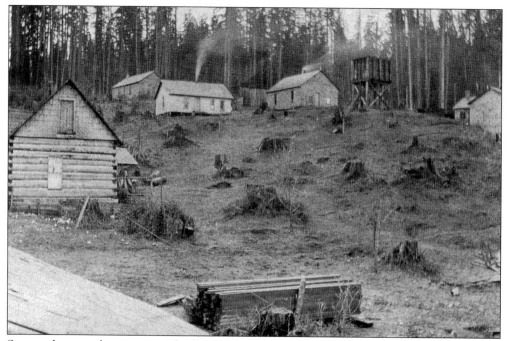

Scattered among the stumps are dwellings that constitute the settlement of Paradise Lake around 1900. Nearby was the large Paradise Lake Shingle Mill, whose workers harvested the cedar stumps remaining after the trees were logged and sent to mills for lumber. The mill operated from about 1900 to 1904, making and shipping bundles of shingles until the stumps disappeared. A cookhouse, school, and cemetery also served these workers and their families.

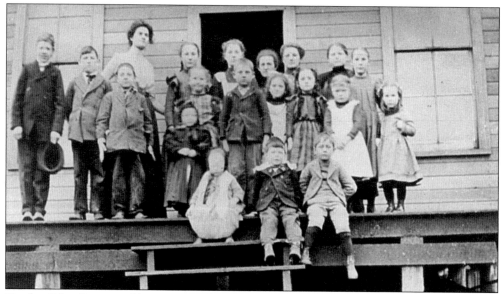

Teacher Edna Swain could expect anywhere between 18 and 20 pupils, grade one through eight, when she convened each morning at Paradise Lake School in 1901. The school stood adjacent to the huge shingle mill and doubled as a community center for the families whose homes were clustered around the mill. The school lasted three years, until the mill closed and the settlement died out.

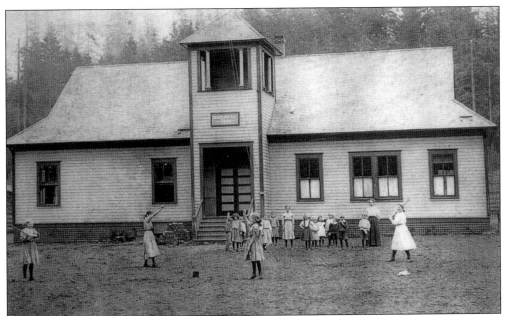

Girls of all ages enjoy a softball game in front of Grace School in 1910. A 10-by-12-foot cabin was the first schoolroom when Bear Creek School District formed in 1889. Soon, families settled around numerous shingle mills at Grace, and by 1905, this 40-pupil schoolhouse was built. By 1929, only nine pupils remained, while 18 high school–aged students were going to Bothell. The building then became a grange for decades.

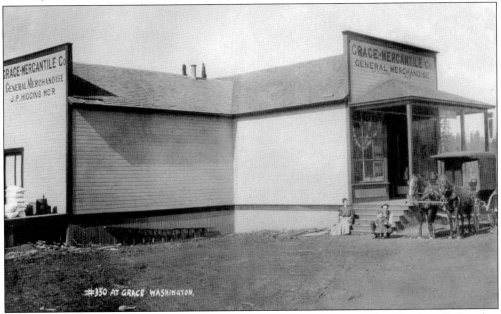

Grace Mercantile opened in 1908 to serve a small settlement around the Woodinville Lumber Company mill north of Woodinville. The store, on company property, was managed by John P. and Mary Turner Higgins and acquired a post office in 1909, which closed with the mill in 1911. The mercantile lasted until 1912. Later, the Seely family operated a farm on the property. The land became the site of Fitz Auto Wrecking.

Arthur and Caroline Peterson and their son Robert rowed across Lake Washington and up Squak Slough in 1876 to homestead 160 acres in the valley. The land spanned the slough from today's Hollywood intersection west across the valley. When Arthur died in a logging accident, Caroline proved up the claim and raised their four sons. Pictured here are, from left to right (first row) George, Caroline, and Fred; (second row) Arthur and Robert.

S.M. Duffield and his 22 pupils line up neatly in this 1908 photograph of the Derby School, preceding today's Hollywood Schoolhouse on the same site. The 1892 school served families along Squak Slough and the Woodinville-Redmond Road, operating each year as long as money held out. For the remainder of the term, children boarded the morning train at the crossing and rode down the valley to Woodinville for school.

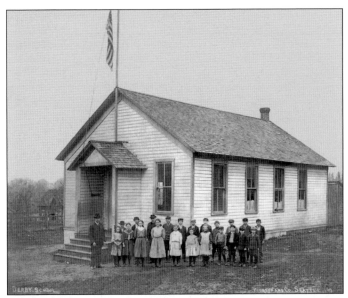

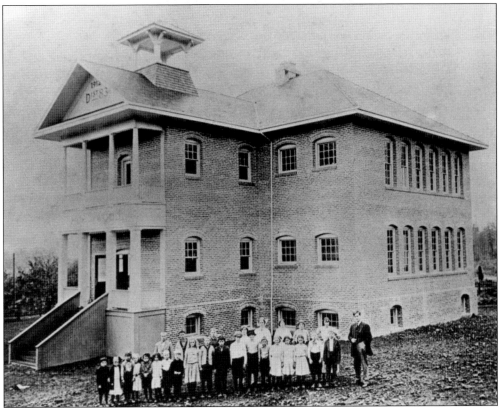

This 1912 brick schoolhouse was financed by Hollywood Farm owner Fred Stimson to replace the 1892 one-room Derby school. Stimson petitioned to rename it Hollywood. The school closed in 1921 when the local district joined Bothell Schools, and children were bused to Bothell. The building housed the Sammamish Valley Grange for several decades. Designated a state and county historic landmark, it has since hosted shops, wine-tasting rooms, and special events.

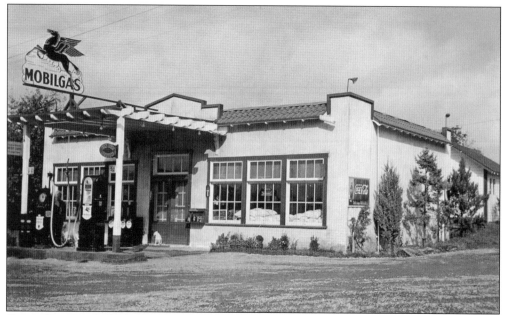

George Peterson built the Homestead Grocery across from Hollywood Schoolhouse in 1924 on the site where his parents homesteaded in 1876 and where his widowed mother provided meals to boat passengers traveling Squak Slough in the 1890s. The store sold in 1953 but continued serving Hollywood residents and motorists until it burned down in 1965. Another service station replaced it and became the Station Pizzeria, with adjacent wine-tasting, in 2012.

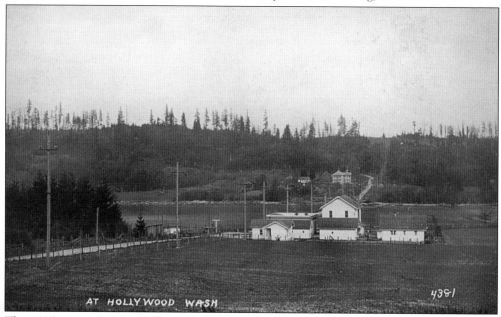

This 1915 postcard of the Hollywood community looks east across the valley. In the foreground is the rear of a two-story building, the Hollywood Store, and a Hollywood Farm cottage. In the distance above the store roof can be seen the 1912 brick Hollywood School and the original 1892 Derby schoolhouse behind it. When Fred Stimson founded Hollywood Farm, he changed the settlement's name from Derby to Hollywood.

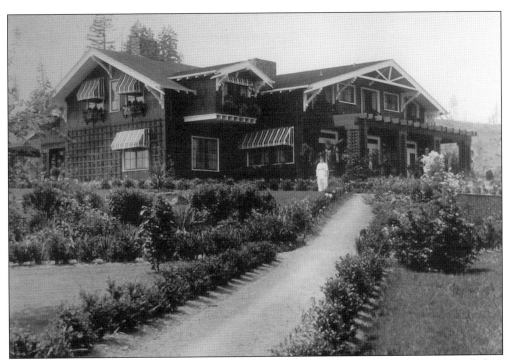

Seattle lumberman Frederick Stimson built this manor house in 1911 as a summer retreat, including servants' quarters and a carriage house. In 1921, Stimson died without a will, tying up the estate for years. Eventually, the Gevurtz furniture store family bought the property. During Prohibition, it is said the Wake Robin Lodge operated a speakeasy in the manor basement. In 1941, Phillip Macbride purchased the property. The house is now a city, county, and national registered landmark. The manor house is currently used for special events by Chateau Ste. Michelle winery.

Frederick Stimson was a wealthy Seattle lumberman with a special interest in farming. In 1910, he purchased 206 acres in the Sammamish Valley to establish a modern Holstein dairy farm as a demonstration project. With more than 100 cows and a prize-winning bull, he established strict sanitation and milking procedures. Milk production began setting records, and Stimson hosted numerous agricultural experts. Unfortunately, he died of a heart attack in 1921.

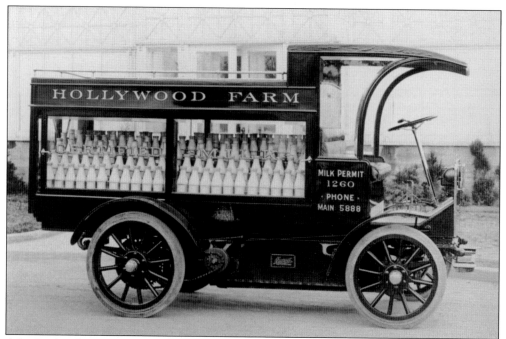

After Frederick Stimson established Hollywood Farm, he initiated delivery of milk from his prize-winning herd of Holsteins to homes and his farm products store in downtown Seattle. This truck was part of his delivery fleet. Although Woodinville mostly had dirt roads, Stimson underwrote construction of a brick road running from his farm entrance to meet one in Bothell.

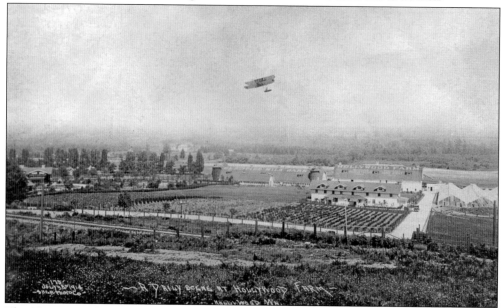

This 1914 postcard of Frederick Stimson's sprawling Hollywood Farm spotlights an airplane soaring over the valley. Viewed from the hillside above are the three-story bunkhouse (right center), the milking barn behind it, and the greenhouses (far right). At far left is the Stimson estate and grounds. The pilot and his biplane are unidentified, although it is known that Fred's son Harold was a pilot and often landed on the farm.

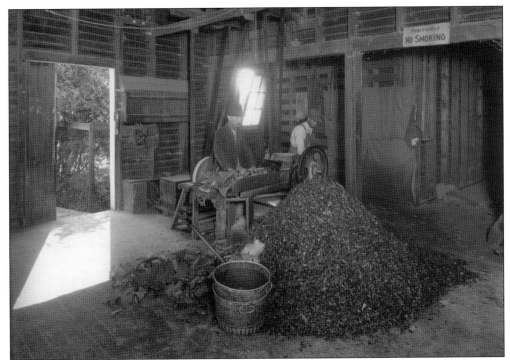

Although green kale is highly regarded for human diets in current times, the leafy vegetable was just as important in 1921 at Hollywood Poultry Farm for Mort Atkinson's championship laying hens. Farm workers pictured here chopped the kale daily as a supplement for the chickens. Atkinson experimented with feed, egg-laying conditions, and breeding stock in developing his champions. By 1930, the farm was shipping 30,000 chicks annually around the world.

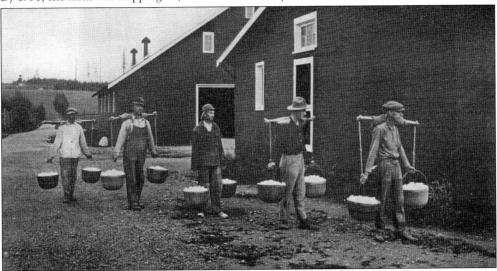

Hollywood Poultry Farm employees carry baskets of eggs they have gathered, about one-third of a day's collection (5,900) in 1916. The farm began in 1913 when poultryman Morton Atkinson partnered with Hollywood Farm owner Frederick Stimson, moving 1,100 hens onto hilltop land that Stimson owned. Emphasizing championship stock and hens that laid 300 eggs annually, the farm was soon shipping chicks, breeding stock, and hatching eggs all over the world.

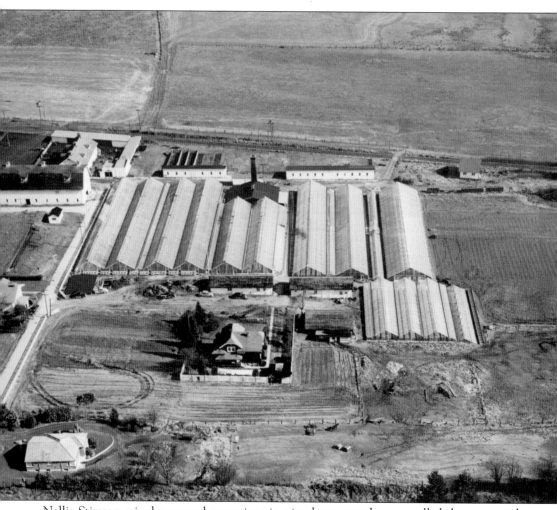

Nellie Stimson raised roses and carnations in nine large greenhouses, called the most modern west of the Mississippi. The flowers traveled daily to her Hollywood Gardens shop in Seattle and destinations such as Alaska and Hawaii. This 1940–1950s aerial view shows four smaller greenhouses added by 1927 purchaser Bert Nicholas, whose fenced home is at center. Nicholas later sold the business to sons Bob and Harold, whose home is at lower left.

Hollywood Hill children Jack and Rose George wait for their school bus in the 1920s, carrying their lunches in traditional lard buckets. Their parents, Joe and Lillian George, cleared his land in the early 1900s and hauled materials up a trail from the Derby School to build their first house. The George family lived on the same NE 165th Street home site until the 1960s.

Hollywood Hill pioneer Joe George and his children, from left to right, Joe Jr., Dorothy, Rose, Lois, and Jack, are bringing in the hay in this 1925 scene. George first cleared his acreage in the early 1900s and built a one-bedroom house, hauling the materials up a trail from the Derby school. He and his wife, Lillian, married in 1915 and had seven children. He added an annex and a larger home in later years.

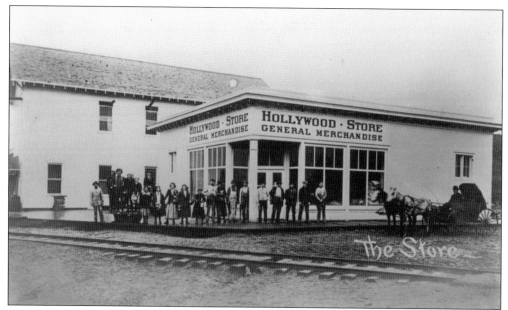

Fred Stimson built the Hollywood Store, where people are pictured awaiting the train. The rear structure had been built in the 1890s along the railroad tracks when the area was called Derby. The main floor housed a store, and a dance hall occupied the second floor. Across the road was a small structure serving as a railroad flag stop for passengers. When Fred Stimson acquired land in 1910–1912 for his Hollywood Farm, including this building, he renamed the area Hollywood.

Police investigate an accident at Hollywood Corner in the 1940s. The Texaco station was built by Andrew Larson in 1923 as Hollywood Corner Service Station. Later known as Mabel's Tavern for decades, it was enlarged and rechristened Hollywood Tavern in 2013. Visible at right is a building where Beryl Johnson repaired automobiles until opening Woodinville Motors downtown. The hillside house belonged to Rosa Carlson, sister of Mary Larson.

Nine

LATER YEARS

Woodinville has undergone at least three makeovers since Ira and Susan Woodin rowed up Squak Slough to homestead in 1871.

The early years were defined by logging and lumber mills well into the 1920s. After the trees were removed and people discovered the rich alluvial soil, farming and agriculture reigned from 1920 to 1960. Truck gardens, dairy farms, and greenhouses defined the major enterprises. By 1929, the community had 780 people and a school population of 85.

By the 1960s, Woodinville was bounded by I-405 on the west and State Route 522 on the northeast. Land developers turned the hills and meadows into home sites for commuters, and the population boomed. Six elementary schools, two junior highs, and a high school were needed to house the burgeoning school enrollment. Streets and roads that began as dirt, then gravel, and finally paving could hardly stay apace. Woodinville got its first signal lights in the 1970s.

Meanwhile, the business community expanded rapidly. Molbak's Greenhouse turned into an international byword among horticulturists. Norm's Resort on Cottage Lake gained national exposure by sending bumper stickers and signs home with visitors from every state. Hollywood Poultry Farm became the Heisdorf-Nelson Farm with a satellite laboratory, known throughout the world for chicks and prime egg-laying stock.

Chateau Ste. Michelle winery acquired the former Hollywood Farm and built a château-style building south of Woodinville in 1976. Haviland (renamed Columbia) Winery joined Ste. Michelle several years later, and many more followed suit. By 2015, more than 100 wineries and tasting rooms dot the valley, a number of them winning acclaim in national wine-judging competition.

After three tries, Woodinville incorporated in 1993, forming a mayor-council form of government and taking up quarters in the historic Woodinville schoolhouse. Entering the 21st century, Woodinville government moved into a new city hall in 2001 and boasted a population of 11,234 in 2012. The community that began in a forested clearing beside Squak Slough is now a modern city astride the Sammamish River.

The Woodinville Tavern was a popular hangout with locals in the 1950s and 1960s. The location originally hosted Boyd's Place, a grocery and gas station owned by Boyd Hargus. This 1956 photograph shows a somewhat rare 1947–1948 Lincoln Zephyr sedan with a V12 engine. Visible at left is the former Hargus Hotel, which stood until the spring of 1961. (Courtesy WSAPSB.)

Summit fire chief Art Nelson inspects the crumbling shed that once housed Woodinville's first fire truck. In 1947, several men formed the Summit Volunteer Fire Department and bought a used pumper truck for $500. Fred Luzzani donated his former chicken coop to house the vehicle, and a levy provided funds for a station in 1950 on land donated by Claude Hinman on the crest of Summit (now White Stallion) Hill.

DeYoung Feed Mill expanded considerably after would-be safecrackers entered the building in 1957 to blowtorch the safe and managed to burn down the mill. This 1984 aerial photograph shows multiple steel silos producing 6,000 tons of bulk feed for poultry, cattle, hogs, and horses as well as retail feeds each month. Ralston Purina bought the company in 1984. Later, it became Ferndale Grain, until being demolished in 2000.

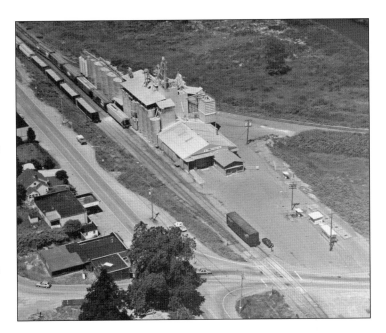

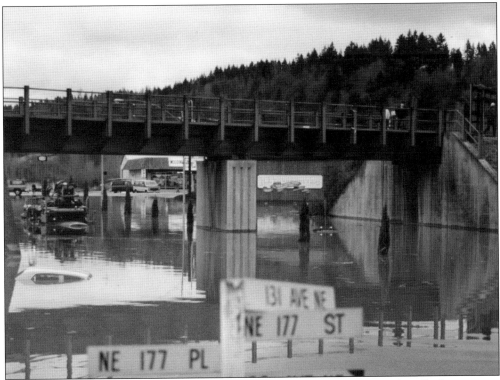

When State Route 522 was completed with an exit ramp leading into Woodinville, heavy rains invariably meant Little Bear Creek would flood under the railroad trestle where the exit ramp intersected with NE 175th Street. After a number of years, the problem was solved with larger culverts to handle the stream flow. Beyond the trestle, Woodinville Hardware (1959–1986) can be seen, since replaced by an Arco gas station.

Woodinville Methodist Church stands on 140th Avenue NE, far from its 1870s origin in Ira and Susan Woodin's parlor. The congregation moved into its own frame church in 1905, across from the school. Fortunately, this larger church was nearly finished in 1957 when an errant motorist struck the smaller church, knocking it off its foundation. Since that time, the church has added classrooms, offices, and a larger sanctuary.

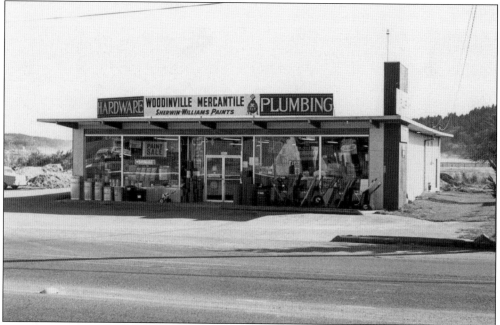

The go-to store for all hardware and plumbing needs in Woodinville for more than 20 years was founded by longtime businessman John DeYoung in 1959, facing the main thoroughfare at NE 175th Street and 130th Avenue NE. The business was purchased by Bob Woods in 1965 and continued in operation until 1986, succeeded at the site by an Arco service station.

These aerial views of Woodinville contrast the small business district (lower left) along Front Street in 1936 (above) and the urbanization along NE 175th Street and beyond. By 2002 (below), the Sammamish River had even been dredged and straightened by the US Army Corps of Engineers. Now an incorporated city since 1993, Woodinville's population is more than 11,000. However, the original business district remains at far left.

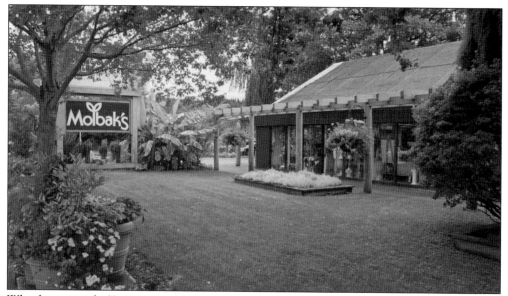

What began nearly 60 years ago as five small greenhouses on Woodinville's main street has become a must-see tourist destination with 28 greenhouses, a gift shop, and retail garden store. Molbak's Nursery is the largest garden center in the Northwest. The business is especially popular during December holidays, when thousands of visitors view the wide varieties of poinsettias and enjoy complimentary Danish pastries, a tribute to the Molbaks' heritage.

Egon and Laina Molbak came to Woodinville from Denmark in 1956, following Egon's stay here in 1948 as a horticultural exchange trainee. They bought the Nicholas Greenhouses on NE 175th Street and began operating the business and raising a family. Today, the internationally known Molbak's Nursery continues under direction of their son Jens. In this 1983 portrait, Laina and Egon are surrounded by, from left to right, Kirsten, Jens, Heidi, and Ellen.

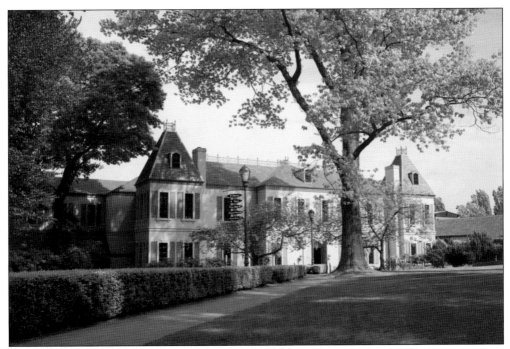

Chateau Ste. Michelle is the oldest and largest winery in Washington state. Featuring spacious grounds and a sweeping view of Mount Rainier, Ste. Michelle is the focus of Washington wine tourism. Launched in 1974 when US Tobacco acquired a Seattle company whose roots date to 1934, the French-style château opened in 1976 on the 1912 site of the former Hollywood Farm. Dozens of specimen trees planted by Fred and Nellie Stimson more than 100 years ago now provide a lush setting for visitors.

Two hot-air balloons hover over Cottage Lake, east of Woodinville. Favorable wind drafts and varied scenery first attracted balloonists to the area as early as the 1970s. Dozens of these colorful orbs drifted almost daily over Woodinville hillsides and lakes, usually landing in the Sammamish Valley with their passengers. Occasionally, however, a balloon would make an unscheduled landing in a backyard, large tree, or lake.

A weekly sight in Woodinville from 1993 to 2007 was the *Spirit of Washington* dinner train. Customers boarded in Renton and rode to Woodinville along the former Lake Washington Belt Line roadbed, stopping at Chateau Ste. Michelle and later Columbia Winery for a tour and wine tasting as part of the excursion before returning. The 1950s General Motors locomotive was diesel electric, producing 1,750 horsepower.

The large rearing horse on the hilltop above Woodinville was said to be erected by Ed Peyser, who operated Ed's White Stallion Tack there in the 1950s, near the Summit Fire Department station. The white stallion is now a familiar landmark along the Woodinville-Duvall Road and a directional icon for the various businesses at 156th Avenue NE, including a restaurant, coffee stand, and assorted service outlets.

Boy Scout Troop No. 422 of Woodinville marches westward on NE 175th Street in the 1984 All-Fools' Day Parade. The annual event, launched in 1978 on the Saturday in April closest to April 1, changed to August in 2013. Accompanying the parade in later years was the Basset Bash, in which basset hounds from across the state competed for titles such as Basset with the Longest Ears.

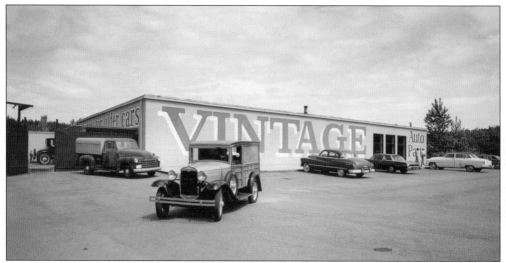

Two brothers, Terry and Jon Jarvis, launched Vintage Auto Parts north of Woodinville in 1966. The shop catered to restoration buffs by stocking parts for most vehicles manufactured in the 20th century. Their customer base expanded beyond the Greater Seattle area to South Korea, Australia, New Zealand, South Africa, and much of Europe. The Jarvises often traveled to numerous states and countries, uncovering old car parts in dusty garages, forgotten barns, and overgrown fields. The Jarvises retired in 2001 after 35 years.

Vintage Auto Parts co-owner Jon Jarvis helps customers inside the store he and his brother Terry opened in 1966. In addition to supplying parts for vintage vehicles long out of production, the Jarvises made buying trips around the country and the world to seek old parts for shipment home to Woodinville. The Jarvises retired and closed the shop in 2001.

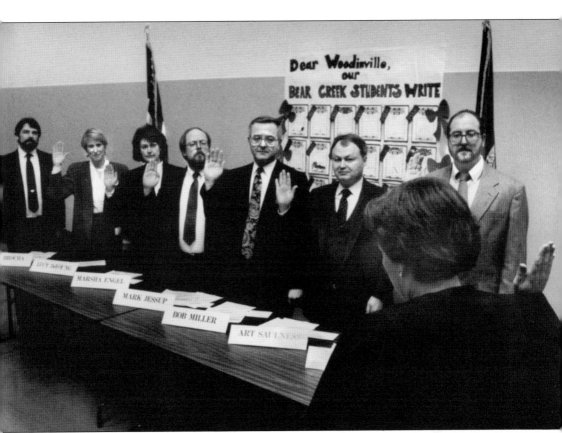

After more than 100 years as an unincorporated community, Woodinville residents voted in 1992 to create a city. They elected a seven-person city council whose members were officially certified in December 1992. District judge Rosemary Bordlemay swears in, from left to right, Don Brocha, Lucy DeYoung, Marsha Engel, Mark Jessup, Bob Miller, Art Saulness, and Don Schneider. DeYoung was chosen as Woodinville's first mayor by virtue of receiving the largest number of votes—1,795.

The City of Woodinville dedicated its new city hall on March 31, 2001, after using nearby Woodinville Schoolhouse as initial headquarters for seven years. The city was formed with voter approval in 1992, after the third try for incorporation. As of 2012, the population was 11,234. The city has a council-mayor form of government with a hired city manager who oversees operations.

Multiuse ball fields in an attractive setting greet motorists entering Woodinville from State Route 522. The fenced, lighted fields are used year-round by all ages for baseball, softball, soccer, and Little League activities. The large site once housed small businesses and the playfield for nearby Woodinville School students over the past 120 years.

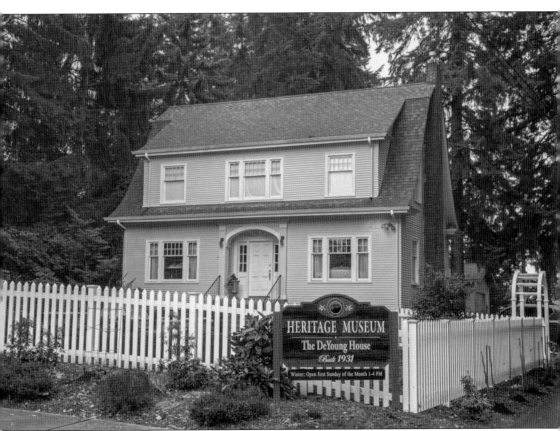

The Woodinville Heritage Museum is housed in the historic DeYoung House. The 1931 Dutch Colonial originally stood on NE 175th Street (see page 80). The house was moved to its current site on NE 171st Street in 1973. Two sons of the original owner, Lowell and Al DeYoung, purchased the house and donated it to the Woodinville Heritage Society. The museum opened in 2011.

DISCOVER THOUSANDS OF LOCAL HISTORY BOOKS FEATURING MILLIONS OF VINTAGE IMAGES

Arcadia Publishing, the leading local history publisher in the United States, is committed to making history accessible and meaningful through publishing books that celebrate and preserve the heritage of America's people and places.

Find more books like this at
www.arcadiapublishing.com

Search for your hometown history, your old stomping grounds, and even your favorite sports team.

Consistent with our mission to preserve history on a local level, this book was printed in South Carolina on American-made paper and manufactured entirely in the United States. Products carrying the accredited Forest Stewardship Council (FSC) label are printed on 100 percent FSC-certified paper.

MADE IN THE USA